he Sacramento Public Library gratefully acknowledges this contribution to support and improve Library services in the community.

In Memory
of
Jim Wilborn
Supporter and Friend
of
Belle Cooledge Library

GOLF MY OWN DAMN WAY

ALSO BY JOHN DALY

My Life In and Out of the Rough: The Truth Behind All That Bull****
You Think You Know About Me

GOLF MY OWN DAMN WAY

A REAL GUY'S GUIDE TO CHOPPING
TEN STROKES OFF YOUR SCORE

JOHN DALY

with Glen Waggoner

HARPER

An Imprint of HarperCollins*Publishers*
www.harpercollins.com

HarperCollins books may be purchased for educational, business, or sales promotional use. For information, please write: Special Markets Department, HarperCollins Publishers, 10 East 53rd Street, New York, NY 10022.

FIRST EDITION

Illustrations by Ross MacDonald of BRIGHTWORK PRESS

Library of Congress Cataloging-in-Publication Data is available upon request.

ISBN: 978-0-06-143102-9
ISBN-10: 0-06-143102-8

07 08 09 10 11 ID/RRD 10 9 8 7 6 5 4 3 2 1

To Bud Martin

For always being at my side,
no matter how deep the rough,
no matter how tough the course

CONTENTS

GOLF MY OWN DAMN WAY

Introduction

> "Golf and Sex are about the only things you can
> have fun doing without being any good at."
> —JIMMY DEMARET

You know what? Golf and sex *do* have a lot in common. Maybe that's why I'm such a big fan of both.

For instance, if you're taking up either golf or sex from scratch, even a halfway-good teacher is more important in the early going than a great instructional manual. So if somebody gave you your first set of golf clubs and this book as an early Christmas present, put the book on your nightstand for now and take your clubs out to the nearest golf course and sign up for some lessons.

Sex? Same deal, only the golf course may not be the best place to find a good teacher.

Another thing: Don't count on getting much good at either golf or sex unless you're willing to practice, practice, practice. You gotta want it, you know what I mean?

Anyway, I came across these words of wisdom from Mr. Demaret in a little deal called *Golf Quips 2008*, a kind of day calendar in a plastic box with a different golf saying for every day of the year.

I don't need to tell you that golf has more gadgets, doo-dads, paraphernalia, and toys than all the other sports put together. Don't believe it? Check out the gifts display at any department store or sporting goods store the month before Christmas or the week before Father's Day. See what I'm saying?

Like the other guys on the PGA Tour, I'm always getting stuff sent to me from this or that outfit wanting me to endorse it or mention it or wear it or whatever. Most of it's junk, but every now and then something comes along that catches my eye.

That's how I came upon Mr. Demaret's words of wisdom. For all I know, there might be dozens of other golf calendars out there every Christmas season. Good stocking stuffers for the golfers on your gift list, I guess, but not exactly something you absolutely must have to make it from one January 1 through the next December 31. Anyway, I was about to pitch this particular one when the quotation up top from the old golfer Jimmy Demaret jumped out at me—literally. (I dropped the little plastic box, and February 22 flipped over by my foot. Honest.)

Now, I'd heard of the man, but I'd never seen him play or anything, so I asked around about him. I mean, any guy who said anything so smart about golf and sex has got to be worth knowing a little about, right?

Well, it turns out that this Jimmy Demaret was quite a guy. Very colorful. Flashy dresser. Used to play a lot of golf with Bob Hope and Bing Crosby out in California. But most

important, Demaret won 31 times on the PGA Tour, including three Masters titles. You know how many other guys have won as many as three green jackets since 1934, when the little spring meeting in Augusta, Georgia, first began?

Six.

You may have heard of some of them: Jack Nicklaus (6), Arnold Palmer (4), Tiger Woods (4 and counting), Nick Faldo (3), Gary Player (3), and Sam Snead (3).

Pretty good company, don't you think? Now, you certainly got to figure Mr. Demaret knew what he was talking about when it came to golf, so I'm giving him credit for knowing a thing or two about sex as well.

Words to live by, if you ask me: "Golf and Sex, the only things you can have fun doing without being any good at."

But you know, right on as that is, it doesn't mean you ought to stop trying to get better at both.

Get Ready to Play

You've got a 2:00 tee time. It's coming up on 1:30. You and your playing partners have just finished a nice lunch in the clubhouse. You're all relaxed, and you're all looking forward to your round, but everybody agrees you've got just enough time for one more beer before you tee 'em high and let 'em fly.

Okay, read my lips: *No!*

You read them right: I said *No*, as in "No One for the Road."

"What's that he said? *John Daly* telling us not to have another round of beers? What's wrong with this picture? Has he given up beer or something?"

The answers to your four questions are You Heard Me Right, Yes, Nothing, and Hell, No.

Look, the Lion hasn't gone and changed his spots or cut off his mane or anything. It's just that we're supposed to be talking here about the best way to knock 5 to 10 strokes off your score so you can enjoy the game of golf a bunch more, not how to drink a bunch more beer. I'm guessing we both know how to do that. So trust me and follow my thinking here.

See, I think that the best way to knock a stroke or two—maybe more—off your score on the *first four holes alone* is to

spend the 30 minutes before your tee time down at the range getting ready to play instead of back up at the clubhouse or over in your cart knocking down beers.

It's simple, really. There'll be plenty of time for beers later, but the time to knock a stroke or two off your combined scores on the *first four holes* is right now. You heard right: I'm saying you can lose a stroke or two on your first four holes by spending half an hour or so down at the range before you tee off.

Help me out here. Think back on the last five rounds you played with *no time* spent at the range. (Most amateurs I know, that would be the *last* five rounds they played.) You know, times you were still in the parking lot tying your shoes when the starter called out for the next group—you and your buddies—to stand by near the first tee. Or the times you were hustling over from the clubhouse at five minutes before 2:00.

Don't pretend you don't know what I'm talking about. Traffic was heavy, or you had some damned-fool "honey-do" chore to finish at home, or some other good excuse. Or you just had to have you that wedge of pie and coffee—or beer— in the clubhouse.

Whatever, you got to the first tee with only just enough time to swing your driver as hard as you could about ten times to "loosen up." (You're doggone lucky you didn't pop a pucker string or something.)

Next thing you know, you're up on the tee box, telling yourself to relax and swing nice and easy. You stare long and hard down the middle of the fairway, trying to visualize your

shot like all the golf magazines tell you to do. Then you give the Big Dog a pro-quality waggle, suck in a deep breath, and take a mighty rip at the ball.

Duck-hook, OB. First-hole mulligan? Sure, you betcha. Next, on what the cranky old USGA says is your third shot, you hit a dying quail about 200 yards into the thick gunch on the far right. You go down and find it (if you're lucky) and hack it out about 50 yards. Next you skull a worm-burner to about 75 yards short of the green, smooth a soft wedge to about 20 feet ("Great shot, partner!"), and 3-putt because you're still so pissed off about that fiasco off the tee.

Let's see now, one, two . . . okay, we'll put you down for a 7.

Triple bogey, *with* your mulligan.

Or a big fat 9—Snowman with a Top Hat—if some asshole in your foursome insists that you play by the Rules of Golf.

Shit, either way your day is done, scoring-wise, before you can even make it over to number 2 tee box.

Sound familiar? I bet it does. Maybe it's not that bad all the time. (If it's worse, don't tell me.) But when it is, I don't need to tell you that it puts you into a hole you never crawl out of. More likely, you dig yourself even deeper over the next three holes.

So let's go back now, and you tote up your scores on the *first four holes* of the *last five rounds* without any time at all, or hardly any, at the range before teeing off. Go ahead. I'll wait.

Just kidding. I don't really expect you to remember your exact scores on the first four holes you played *yesterday*, much less the last five rounds. But the point I want to get across here is that you *almost always* score worse on those first few holes when you spend *no time* at the range than you do when you give yourself a *little* time—say, 30 minutes—to *get ready* to play.

Not to be disrespectful or anything, but you better golfers already know this. There's no single-digit golfer on the planet who'd even think of walking out to the first tee cold, with no prep time whatsoever. A guy that good, he'd rather stay home and mow the yard rather than go tee off without *getting ready* to play. And if for some reason he did, he'd know what to expect: not coming close to playing to his handicap that day because he screwed up those first few holes.

My experience, based on playing in about a million proams and at least that many rounds with friends back at my course in Arkansas, is that the higher a guy's handicap, the more likely he is to shortchange himself on prep time before he tees off, and the bigger chance he has to shoot himself in the foot in the first few holes.

Look, you're not *ever* going to be ready to play as good a round of golf as you're capable of on five minutes of practice swings. You need half an hour, minimum, to get your body and mind ready to play. So if you're really serious about getting to the next plateau—breaking 100 consistently, cracking 80 more often, or playing bogey golf on a regular, nine-

times-out-of-ten basis—start with the one or two strokes you can save with an adequate amount of prep time.

Start with listening to Big John.

Put down that beer in the clubhouse, haul your ass down to the practice range, and spend just 30 minutes there before you tee off.

Get ready to play.

"Great, John. So I go down to the practice range for 30 minutes before I tee off. What should I practice?"

Nothing. I don't want you to "practice" anything. Who said anything about practice? I want you to get ready to play. There's a difference.

Look, I know they call it the "practice range," and even if you call it "the range," it's only natural that you think that you ought to practice something when you go there.

Fact of the matter, I personally believe the best place to practice is out on the golf course. Back home at my course in Arkansas, late on a pretty summer day when everybody's finished their rounds, I'll grab my shag bag, go out to a hole as far from the clubhouse as I can get, and hit balls for half an hour or so, until it gets too dark for me to see what I'm doing. Different kinds of shots from different spots. Whatever type shot I feel like working on at the time. It mellows me out, and it's a helluva lot more interesting than hitting ball after ball straight down a range.

Try it sometime. Of course, it helps if you own your own

course, like I do in Dardanelle. But if you're a regular at a lot of public courses, or if you're a member of a club, you've got a better shot at pulling it off with a few balls later in the day. Speak to the pro. Tell him I suggested it.

Let me tell you, it's a *great* way to practice.

But I'll talk about practicing later. Right now, I want to talk about that 30 minutes before your tee time, when I want you to go the range and *not* practice.

I want you to go there and *prep*.

"Stop right there, John. Practice? Prep? What's the difference?"

Hey, I thought you'd never ask.

Practice is when you work on your game. You tinker with things—maybe your alignment, maybe your takeaway, maybe even your grip. You try hitting different kinds of shots with the same club. You work on hitting a certain kind of shot with different clubs. You break things down and put them back together.

Me, when I'm in a practice session, I'll almost always go into a bunker and hit a bunch of one-handed sand shots— long ones, short ones, whatever—to start off. It helps my feel for the shot, helps my rhythm.

Practice usually lasts an hour, sometimes a little more. Not a whole lot more, though, because after a while your mind tends to wander—hell, *my* mind tends to wander—and you're not really focusing on what you're doing and why.

And prep? Lemme tell you, prep is a whole different thing.

When you go down to the range to prep—*to get ready to play*—you're not going to hit a bunch of different types of shots. You're not going to tinker with your grip, your stance, your takeaway, or where your elbow is midway through your backswing. You're not there to *fix* anything.

You're definitely not there to take your game apart and put it back together. Save that for some other time.

Now is the time for getting yourself mentally and physically ready to play.

"Great! So what do I do—hit a bunch of drivers to give me confidence about getting off the first tee with a good one?"

That's exactly what I *don't* want you to do.

I do *not* want you down there hitting a bunch of drivers before your round.

But I know that's exactly what most double-digit handicappers *do* choose to do when they "warm up" before playing. They go down to the range and bang drivers until they've worked up a sweat, then they head on up to the first tee worrying about that last big banana slice they hit—and, more often than not, they hit an even bigger one.

Let me give you a better plan for organizing that 30 minutes of prep time.

Start with three-footers. That's right, three-footers. Most high-handicap amateurs I've played with will go to the putting green, throw down a few balls, and start banging out 25-footers, one right after the other. Then they'll go down to the hole, knock everything over to another part of the green, and do the same thing.

Let me ask you a question: What is the one shot that most feels like a knife in the gut when you miss it? A damn three-footer to save par or bogey. Makes you want to pick up the damned ball and throw it into the woods, doesn't it? There's *no* feeling worse on a golf course than not making that "make-able" short putt.

So why spend all your time on the putting green stroking 25-footers and none of it on the little stuff? Hell, probably the worst thing that could happen would be if you made one of those 25-footers near the end of your time on the practice green. You'd walk off feeling like you'd just taught yourself how to putt like Tiger Woods. Fact is, you haven't learned anything that's going to help you on those first four holes.

So start with three-footers. My guess is you'll find it easy enough to drain 'em, what with them not meaning anything yet. That's okay. They're not counting toward your score, but they are counting toward your *feel* for your putting stroke. And they're sure as hell counting toward your

mental makeup the first time you have a three-footer for par or bogey out on the course.

Next, move out to the 25 feet. From there, I want you to focus on getting down in 2. Mentally, you've already got that second putt made, right? So that cuts your job down to getting close. *Three feet*, close.

Now, this next bit may sound a little odd, but go with me on it. I want you to putt out every one of those 25-footers that end up three feet or closer. Putt 'em out, even the tap-ins. And the ones that roll more than three feet past the hole? Those I want you to knock back to the 25-foot mark and try again to get three-feet close. Don't putt out unless you've got three feet or less.

By the way, did you notice that I just referred to long putts that rolled "past the hole"? This is as good a time as any to mention that *every* long putt that doesn't go in (and that would be most of them) ought to go past the hole. Maybe you've heard the expression, "Never up, never in?" Yeah, I thought you had. But you'd be amazed—I know I always am—by the number of amateurs who consistently, *consistently*, leave their putts short of the hole. That is, without question, the number one sin on the greens by amateur golfers.

You have *got* to give the ball a chance to go in the cup. That should be the last thought that goes through your mind before you bring back your putter: *Get . . . the #@&%*! ball . . . to . . . the . . . #@&%*! hole.*

CHIPPING AND PITCHING: 15 MINUTES

If I've seen it once, I've seen it a thousand times. A guy in my pro-am group gets off the first tee okay—by that, I mean he ends up in the fairway, doesn't matter how far. His second shot, he underclubs and comes up 15 to 20 yards short of the green. Not half bad, considering he's probably got a swarm of butterflies inside his belly trying to take over his whole body. So now he sizes up the most important shot of the hole. Slightly elevated green that slopes off sharply at the rear. Pin at the back, so plenty of green to work with. Good lie. *No problema.*

Uh-uh, I'm afraid there is one little *problema.* Don't forget, this is the part of the game that most requires feel, touch, control—and practice. And guess which part of the game most amateurs practice the least? You guessed it.

And so our friend, who by the way spent all his time down on the range before tee time hitting driver after driver, stands up over his ball with a pitching wedge in his hands. He stands there a long time as if he's trying to remember what to do. Then, finally, he brings the club back. But halfway through his downswing, he gets scared of hitting it over the green, tries to slow down his swing, and chili-dips the sucker.

Next shot, about 10 feet closer to the hole, he tells himself he damned well won't do *that* again, so this time he rushes

his downswing and skulls a bullet over the green down a little incline where the ball finally comes to rest—about 15 to 20 yards from the green.

Okay, I'm exaggerating, but not by much. Over and over again, I've seen amateurs screw up that shot from around the green, the one that at the end of the day will make the difference between shooting bogey golf and shooting . . . well, you tell me.

And tell me one other thing. Do you think it's possible that 10 to 15 minutes spent chipping and pitching before teeing off would have given our friend a better feel for that around-the-green shot the first time he encountered it?

I sure do.

FULL SWING: 5 MINUTES

"Whoa, there, Big John. You're telling me to spend just the last *five minutes* of my pre-round prep time hitting my driver?"

Who said anything about hitting your driver? I want you to spend your last five minutes of pre-round prep on your *full swing*. And I want you to leave your driver in the bag.

That's right, the guy whose personal motto is "Grip It and Rip It" wants you to leave your driver in the bag while you're getting ready to play.

Hear me out. I'm not telling you to leave your driver in your bag all day. Hell, golf is supposed to be fun, isn't it? And what's more fun than letting the big dog eat?

But I am telling you that you'll get more benefit out of swinging another club besides the driver in that little bit of prep time you've promised me you'll spend from now on before you tee off.

The club I want you to use is your second-shot club.

Which club is that? You tell me. It's easy enough to figure out. Let's say the average par 4 is, what, 425 yards long? If you're like me and you hit it about 325 off the tee, you've got about 100 yards left to the hole. For me, that's an easy sand wedge.

What's that you say? You're more like 225 off the tee? 250? Doesn't matter. The club I want you to swing down on the range before you tee off is the club you find yourself using most of the time for your second shot on ordinary par 4s.

Think about it. You'll get the benefit of making full swings, but without the downside of swinging too hard, which most people invariably do when they get a driver in their hands.

So figure out what you would normally hit *after* a normal drive on your average 425-yard par 4. Maybe at your course, from the men's tees, it's only 400 yards. Whatever, calculate what you have left to the green.

For the sake of argument, let's say it's 150 yards. Then take out your 150-yard club, whatever it is, *and* your 160-yard club.

Why the second club? Well, let me answer your question with a question: When was the last time you flew a green with your approach shot? I'd say that something north of 90 percent of the amateurs I've played with come up short of the green with their approach shots, and for one simple reason: under-clubbing. If using both clubs during prep time makes you more open to going to, say, a soft 6 instead of a hard 7 on your approach shots when you're doing it for real out on the course, then think of this tip as a little bonus.

Right about now you might be thinking, so what club does John swing down on the range before he tees off? Fair question. With me it's a little different: I usually hit full-swing pitching wedges just before a round. That's often my second-shot club, sure, but that's not the reason I go to it. I usually hit wedges before teeing off because I want to have the rhythm and feel of hitting a wedge fresh when I put my hands on my driver.

Now that I think about it, that could be a good option for you as well, depending upon how long a hitter you are. The goal's the same: get ready to play but without spending the short time you have trying to kill a bunch of drivers, which I believe will do you more harm than good.

Time to go. Your foursome is up next. You've prepped for 30 minutes, and you've covered all your bases: putting, chipping, pitching, full swing.

Now you're ready to play.

→2←
Be an Athlete Out There

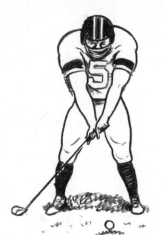

What I mean by being an athlete out there is . . .

"Wait a minute, John. I'm a golfer, not an athlete"

Old, old joke. And it's only true if you let it be. Later on, I'm going to talk about flexibility exercises and a few more drills that'll help you play better golf. Yeah, me, John Daly, talking about exercise. (Stay tuned. This could be historic.)

But what I mean by being an athlete out there has to do

with how you *set yourself* and how you *feel* when you are up there on the tee or out on the fairway.

I want you to be in an athletic position.

Think about how a middle linebacker sets up over the center. His weight's on the balls of his feet, he's crouched forward a little, his body's loose, and he's ready to go either way at the snap of the ball.

Or think about how a basketball player sets up on D. His weight's on the balls of his feet, he's crouched forward a little, his body's loose, and he's ready to go either way as the guy with the ball dribbles toward him.

No, there's not an echo in here. The common denominator is that both are in an athletic position.

See what I'm saying?

When you set up to hit a golf ball, I want you to be an athlete out there. That is, weight on the balls of your feet, crouched forward, body loose. You don't have to be ready to go anywhere, because you're staying put. But otherwise, you're set up pretty much like a linebacker or a basketball player.

Like an athlete.

·3·
Never Hit a Shot Without It

Never, ever, hit a shot without going through your pre-shot drill. Not on the practice range, and certainly not on the golf course. Your pre-shot drill is critically important to your golf game because it focuses your mind on all the keys to putting a good swing on the ball. Here's mine:

1 Stand behind my ball and set my target line. Mr. Harvey Penick said it best: "Take dead aim."

2 Visualize my shot soaring through the air exactly on the line and trajectory that feel best for the situation.

3 Walk up to my ball and take my stance: square alignment, feet parallel to target line.

4 Check my ball position: off inside left heel for driver, more toward the center as the club I'm using gets shorter.

5 Check my upper body: arms hanging straight down from shoulder, hands in perpendicular line with chin and ground.

6 Check my ball position by imagining a line

straight up at a 90-degree angle from the ground: If it touches inside my chin, it's too close; outside my forehead, too far away.

⑦ Check my grip: The V's formed by my thumbs and first fingers are pointing just right of my chin.

⑧ Look/waggle. Look down the target line, then back at my ball, and waggle my club head over it. Four looks, three waggles. No waggle after fourth look. Time to let 'er rip.

⑨ Exert slight *(slight!)* increase in grip pressure on fourth look. I'm reluctant to include this, because I've made such a big deal of you relaxing your grip. But for me, an ever-so-slight increase in grip pressure is my way of saying it's time to get down to business. You know—Grip It and Rip It.

As I said, that's *my* pre-shot drill. Looks like it takes forever, but it really doesn't. You'll soon learn to do it without thinking, but you must always remember to do it. And while I might shorten my pre-shot drill some with middle- and short-irons, I *always* follow it to the letter when I hit driver. You don't have to copy it. Prefer three looks and two waggles? Two and one? Be my guest. It all depends on what you're comfortable with.

Just don't try to get away with, say, ten looks and nine waggles. If you were to do that at the Lions Den in Darda-

nelle, I'd have to get someone to politely ask you to remove your butt from the course—unless your playing partners hadn't already come up the side of your head with a 2-iron.

But whatever mix you settle on, go through your pre-shot drill *every* time. Trust me—grooving your pre-shot drill will help your groove your golf swing.

Before You Rip It, You Gotta Grip It

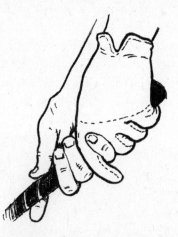

How you grip has a lot to do with how far you rip.

I'm not talking about whether you use an interlocking grip or an overlapping grip. That's a matter of personal choice based on the size of your hands and what feels good.

Some guys with large hands and long fingers prefer the overlapping grip, where the little finger of right hand lays on top of the first and second fingers of the left hand.

I have average-size hands and fingers, so I feel more comfortable with the interlocking grip, where my right little finger is laced between the first and second fingers of my left hand. I feel like it gives me more control over the club.

(By the way, except for Bob Estes, I don't know anybody

today who uses the two-handed or baseball grip, but I guess it's an option. It's worked pretty doggone well for him.)

And when I say that how far you rip it depends on how you grip it, I'm not talking about whether you use a "strong," "weak," or "neutral" grip.

You understand, I'm sure, that strong, weak, and neutral don't mean "Macho," "Wuss," and "I Don't Give a Shit." The first means you're trying to play a draw, the second means you're trying to play a fade, and the third means you're trying to hit it dead straight.

The terms have to do with where you fit your hands onto the club. Turned a little to the right is strong. A little to the left is weak. Square on the club, not fudged either way, is neutral.

The way you tell for sure one from the other is by looking at where the V's formed by your thumbs and first fingers point when you grip the club. Strong is when the V's point just to the right of your chin, weak is when they point just to the left of your chin, and neutral is when the V's point straight at your chin,. Strong sets you up for a draw, and weak encourages a fade.

A majority of the players on the Tour use a neutral to strong grip. The reason for that is that a neutral-to-strong grip allows them to release the ball properly through the hitting zone from a shallower angle of attack. A "weak" grip tends to promote a steeper approach to the ball, which can produce a more inconsistent flight pattern.

I use a slightly strong grip. I say that if you can grab an

advantage off the tee, go for it. Hit a controlled draw with 20 extra yards and you're ahead in the game, literally and figuratively.

If you tend to slice, and you probably do, I recommend that you use a strong grip, too. It won't cure your slice, not by itself, but it'll start you on the right road.

But as I said, it's not whether your grip is interlocking or overlapping, strong or weak or neutral, that has the biggest effect on how long you rip. It's how *hard* you grip the club.

Make that how *light*, because I always want you focus on what you want to do, not what you don't want to do. So think *light* when you grip your club—all of them, but especially your driver.

Shit, I'll see guys squeezing a club like they were trying to wring out a washrag. Their biceps get all pumped up like balloons. You wonder the damn club doesn't start screaming for mercy.

The result? They cut down on the potential length of their backswings by 25 percent or more. Shorter backswing equals shorter distance. End of lesson.

Prove it to yourself. Go to the range and hit five balls squeezing your club real tight. Try to remember how far you got the clubhead back when you took your backswing. And check how far your drives go.

Now, loosen your grip so that it feels like you're barely holding onto it. It'll maybe feel funny at first, like you might lose control of it on your backswing and take out somebody standing at the other end of the tee box. Don't worry, you

won't. See, the very act of starting your backswing will firm up your hold on the club so there's no fear of it flying off.

So go ahead and hit five more balls. Trust me, you'll feel the difference—and you'll see it. It's simple. The lighter your grip, the longer and more flowing your backswing. And the longer your backswing, the farther you can rip it.

Sam Snead said it better than anybody: Hold the club like a bird—you don't want it to get away, but you don't want to hurt it.

And while I never saw him play, I've been told that Mr. Snead could flat-out rip it.

→5←
Get Your Head *Out* of the Game

The number one obstacle to hitting a good golf shot is your head. Not moving it or anything. *Using* it.

That's the plain truth.

Your average golfer steps up to a ball out on the golf course and starts thinking a mile a minute. What's my target line, how's my grip, where are my elbows, take it back low and slow, remember to pivot, should I ask that new account executive out next Friday, time to cock my wrists, shift my weight, bring my shoulder down and through—what'd I forget?

Shit, with all that thinking going on, it's a wonder every swing doesn't end up a whiff.

Let me tell you, by the time I'm ready to start my swing, I've stopped thinking. I've looked close at my lie, I've checked my distance, I've factored in the wind, and I've figured out where I want the ball to end up—all *before* I step up to the ball. Then what I try to do is go blank. Not consciously think about *anything.* Just swing the club.

That's what "Grip It and Rip It" was all about when I won the PGA in 1991. That's the way I approach the game today.

Sounds easy, doesn't it? Okay, I know it isn't. The biggest difference between you and me is that I play golf for a living

and you don't, and even so it took me a long, long time to figure out how to stop overthinking everything.

That's why, when I'm doing a clinic or maybe just talking to fans on the range, and somebody asks me for "swing thoughts" to help them put a better swing on the ball, I give them just one: Don't think.

Don't think.

I figure you've already got too many swing thoughts rattling around up there when you're playing a round of golf. If I give you another one, it'll just mess you up more. I don't want you to be thinking while you're swinging, at least not on the golf course.

The practice range, though, that's a whole different thing. That's where I want you to do your thinking, because there you're practicing, not playing—and believe me, that matters. In this book I'm gonna be giving you plenty of *practice* thoughts—not *swing* thoughts—because I want to help you get more fun out of golf, and the best way to that is to play better.

So here's my deal: You promise me you'll clear your head of that long checklist of stuff you're used to running through every time you set up for a shot during a round, and I'll give you my first practice thought to focus on at the range. I guaran-damn-tee you it will help.

Ready?

→6←
Let Your Belly Lead Your Hands

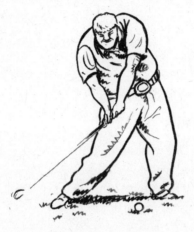

Got that? Let me say it again just to make sure.

Let . . . your . . . belly . . . lead . . . your . . . hands.

It's simple, really. The power in any golf swing comes from turning your body—first back, then forward, as you swing the clubhead through the ball. Don't believe me? Try standing stock-still, *not* turning your body, and swinging the club just using your arms.

See what I mean?

Watch your favorite guy on the Tour—Tiger, Phil, Ernie, Vijay, me, anybody—and forget about his arms and hands

and head when he makes a golf swing. Just focus on his belt buckle.

Think of it as a third eye looking straight down at the ball, on a line perpendicular to the target line. First it turns to the right, away from the target, until it's facing 45 degrees south of where it started. Then, after a tiny pause, the buckle—the *eye*—turns back hard along the target line and keeps on going until it's looking straight at the target.

Then watch another swing, this time trying to focus on your guy's hands in relation to his belt buckle. They're always, *always* just a little behind through contact.

Now you take that tip to the practice range. You can't see your own belt buckle, so focus on that little extra hanging over your belt. (For some of us, that's easier than for others. If you don't have that little roll of extra, you'll just have to use your imagination.)

My point here is that your belly is your key to a good golf swing. As it turns toward your back foot, let your hands follow. *Don't sway! Just turn your belly!* Pause just long enough to let your wrists cock, then turn your belly back along the line sharply and keep on turning until it's facing the target, with your hands following just behind.

Don't think about anything else. Not your shoulders, not your arms, not your elbows, not the club head, not your job, not pulling the trigger on that new rec room your wife wants to add on to the house, not anything.

Just have this one thought:

Let your belly lead your hands.

My One-Hour Research Project

Go to the range *on a day you're not playing*. Starting with your wedges, find out what club you hit 100 yards. A pitching wedge, I'm guessing. But whatever it is, identify it and then hit ten of them. Then find out what club you hit 125 yards. Once you find it, hit ten of them. Then move on to 140, 150, 160, all the way through your bag. In an hour, you ought to be able to establish once and for all—to *prove* to yourself—how far you hit each of your clubs.

That just may well turn out to be the most productive hour you'll ever spend on the range.

Check Your Ball Position

Very funny. But no, I am *not* talking about whether dressing left or dressing right is going to help your golf game. What I'm talking about is the position of your golf ball when you take your stance at address.

• **Driver and Fairway Woods:** Position the ball directly opposite your left heel.

• **Long Irons:** Two inches to the right (toward the center of your stance) of an imaginary line between your left heel and the ball.

• **Middle Irons:** Another two inches toward center, and narrow your stance a couple of inches.

• **Short Irons:** Center placement, but I'll have more to say when I talk about short iron play.

Take a Stance

Stand behind the ball and fix a line *directly* to the point where you want the ball to end up.

Got it?

Now move to the side of the ball with your shoulders pointed *exactly parallel* to the target line you've just established from behind the ball.

Easy? Think again.

Getting your stance right is a whole lot trickier than you think. Let's say you get a dead bead on your target when you go behind the ball. The natural tendency when you walk up to take your stance is to align your feet so that a straight line drawn from your toes runs at exactly to the same target point. Right?

Uh-uh. Your toes aren't going to hit the ball. Your club head is. And if you run a straight line between your toes and the target, and if your club head meets the ball square, and if your ball flight is dead straight, the ball is going to go to the *right* of the target.

Your feet must be set *parallel* to the target. But because of the 24 inches or so between your feet and the ball, a straight line from your toes should shade just to the left of the target if you're going to deliver the ball straight at the target.

Plain geometry, isn't it? As best as I can recall, that's how they teach golf alignment in high school.

But that's just the beginning of a setting up in the right stance.

Next you want to make sure that the distance between your feet is about two inches narrower in width than your shoulders. Too wide a stance and it'll restrict your pivot. Too narrow and you'll lose your balance on the backswing.

Now toe out your right foot a little bit, say 25 percent from perpendicular to the target line. That'll help you get a bigger hip turn.

Still with me?

Good.

Now let's move up the body: Shift your weight slightly so that it's evenly distributed on the balls of your feet; flex your knees slightly; bend your torso slightly at the waist, so that your arms hang straight down from your shoulders; and tilt your chin up slightly so you can look down at the ball from the bottom of your eyes.

Notice how many times I just said "slightly"? That's because too many people hear somebody tell them to do this or that in golf and figure that if "some" is good then "more" has gotta be better. No, sir. Excess can bite you in the ass, in golf as well in most other parts of life. Believe me, I know what I'm talking about here.

So when I say shift your weight *slightly* forward, flex your knees *slightly*, bend your body *slightly* at the waist, and tilt your chin *slightly* up, I do *not* want to see you twisting yourself up like some kind of damned human pretzel in a golf visor.

⇢10⇠

"What About the Hair, John?
Used to Be a Long Mullet. Now It's a Kind of
Modified Buzz Cut. What Gives?"

I'll tell you, partner, but will you please tell me what that question has to do with shaving ten strokes off your score?

Look, if it was up to me, I'd like to have the old mullet down to my butt, but the Tour probably wouldn't let me grow it that long. So I decided to compromise by shaving it all off.

You could say it gives me five more yards on my drive because of less wind resistance.

Bring Enough Stick to the Dance

The number 1 mistake, bar none, that the vast majority of amateurs make on the golf course is not hitting enough club.

I don't care if you've got the purest, most beautiful swing in the world. I don't care if you make clean, solid contact every time. I don't care if you've been living right and thinking pure thoughts ever since that time you went and busted up your ex-wife's car.

If you don't have enough club in your hands, none of that good stuff's going to matter, because you're not giving yourself a chance to hit the green. If you're hitting 8-iron when you should be hitting 7, or even 6, you're going to come up short every damn time.

Think that doesn't really apply to you? Well, let me ask you two related questions:

When was the last time you overshot a green from 150 yards out or more?

When was the last time you came up short?

As I said, make sure you bring enough stick to the dance.

Tee 'Em High and Let 'Em Fly

That's not just one of those bullshit meaningless golf slogans that people are always spouting. It's actually a good golf tip.

Hell, what with the humongous size of driver heads these days, if you teed the ball *low* you might end up taking a divot.

Seriously, though, teeing the ball high makes a lot of good sense.

Remember, the head of your driver *must* be just past its lowest point when it makes contact with the ball. That's an absolute. That's why you position the ball a couple of inches inside your left heel when you're hitting a driver. And teeing it up high encourages a sweeping action that delivers the head to the ball on a *slight* upswing.

So go ahead—tee 'em high and let 'em fly!

See Your Shot *Before* You Hit It

Yeah, I'm talking about visualization, and I know a lot of amateurs think that's some kind of con job. They may not say that out loud, but they're thinking it. They're going, "Yeah, yeah. He's talking about visualization, about 'seeing your shot before you take back the club,' because he has the skills and the experience to make the damned shot in the first place. Forget visualization! Me, I got to think about the position of my shoulders at the top."

To those guys, I have just one question:

Did you ever stop to think that maybe visualization is *one* of those skills, and that it helps me *draw* on my experience?

So where were we? Oh, yeah, I was getting ready to talk about seeing your shot before you take back the club. That would be visualization, which—if you practice it religiously and right—is practically guaranteed to shave a couple of strokes off your score all by itself.

Rule number 1 is to think positively. Don't be going up there, on the tee or on the fairway, zeroing in on where you *don't* want to hit it: "I don't want to hit it left because the rough over there is jail . . . I don't want to hit it right because of the lake . . . I don't, I don't, I don't." The more you focus on where you *don't* want to hit it, the less attention you pay to where you *do* want to hit it. You've nar-

rowed the fairway on yourself before you've even taken the club back. Then, if you try to steer the ball away from the trouble, which you'll subconsciously try to do if that's all you're thinking about, your ball's gonna find a bad place like a rat finds cheese.

Sure, you've got to quick-scan the situation and figure out what's what. But then what you need to visualize is where you *want* the ball to go, not where you *don't* want it to go.

Where it *is* going to go: Fairways and Greens!

Sometimes Tour players will write that above their signatures when they sign an autograph. Sometimes they'll say it to each other before teeing off: "Fairways and greens, pard."

Know why? *Because in golf, when you get right down to it, that's all that matters.*

That's all you should have in your mind when you stand behind your golf ball setting your target line and when you're standing over your golf ball getting set to make your swing: "There's a fairway out there, and I'm going to hit that little white ball to the left-center of it."

And when you get close enough to fire at the green, *that*'s all you want to have in your head—the green. Not that nasty slope on the left. Not that bunker on the right. And certainly not that pond in the back. The green. Period.

Fairways.

Greens.

Fairways and greens.

**"What about the practice range, John?
The 'fairway' there is, like, 150 yards wide. I don't
have to waste time 'visualizing' there, do I?"**

Yes, you do. Otherwise you're just banging balls and wasting your time. And let me tell you, "visualizing" is *never* a waste of time.

I know, it's easy to lose concentration on the practice range. That's why I recommend short sessions—say, 30 minutes, tops. Have a plan, stay focused, get your work, and go to the putting green.

And take advantage of what most ranges do give you to work with—markers, flags, something. Create your own "fairway." Pick a target in it, visualize your ball flying right to it, and let 'er rip.

Fairways and greens!

Watch Your Weight

Not the way you might be thinking. (Hell, I'm not one to talk about how much anyone weighs.) I'm talking about how you *distribute* your weight when you address the ball.

For your driver, your fairway woods, and your long irons, you distribute your weight 50-50.

For your middle irons, 60-40, with the extra on your front foot.

For your short irons . . . tell you what, the setup for short irons is so different, in terms of where you play the ball and how wide your stance is and how you distribute your weight, that I'm going to talk about it separately. But mainly you're looking at 70-30.



⟡15⟡
Quick Question

How come the PGA Tour won't let us wear Bermuda shorts in tournament play? What's that, you can't think of a single good reason? Neither can I.

Check Your Shoulders

T he easiest thing to get wrong in your setup to the ball is also the most important thing to get right: the alignment of your shoulders.

Too often a high-handicapper who's been studying hard trying to get better will carefully take his stance and get his feet, knees, hips, and belt buckle all lined up parallel to the target line, just like he's read, and then he'll give his shoulders a little hitch or twist—and leave them lined up slightly to the left or slightly to the right of the target line.

Trying to get a little looser with shoulder wiggle before starting his swing is a good idea. But thinking that just because everything from his belt buckle on down is lined up parallel to the target line, his shoulders will automatically set up that way too is just plain wrong.

To this very day, I'll occasionally have my caddy or a friend or somebody go back behind me when I've taken my stance on the practice range, lay a club shaft along the tops of my shoulders, then hold it there while I step back and check to see where my shoulders were aiming.

Way too many amateurs think that if their feet are lined up properly, their shoulders will be as well. Not so. And if their shoulders are aligned slightly closed or slightly open instead of square to the target line, it will definitely affect

their swing path and make it harder for them to hit the ball straight. That's because when you swing a golf club, you naturally swing it along a line parallel to your shoulder line. If your shoulders are lined up just to the left of the target line, that's where the ball will start out. If they're lined up just to the right, same deal. Worse still, you might sense this on your backswing and try to make an adjustment of the swing path on the way down, and that'll really screw the pooch.

Avoid a lot of grief. Give yourself a shoulders check every so often to make sure they're in synch with the lower half of your body—aligned squarely to the target line.

⇒17⇐
A Sure Cure
for Bunkerphobia

Terrified of the sand? Most double-digit-handicappers are. Most get scared shitless when they hit into a bunker. I mean, you'd think they'd hit it into the water and had already got a one-stroke penalty. They more or less automatically think that if their ball ends up in a sand trap, it's time to call in the dogs and piss on the fire, because the hunt for par—on this hole, at least—is over. The sand paralyzes them, and they might as well have got that one-stroke penalty—or more—because they don't know how to get out.

Sound like anybody you know?

No matter how many times they've heard some talking-head ex-pro on TV say, "The bunker shot is the easiest shot in golf," people with bunkerphobia bring a snowman mentality into the sand with them, and all too often that bad dream comes true.

I'm here to tell you it doesn't have to be that way. If you're a bunkerphobia sufferer, I think I have the cure. It won't ease your pain every time—neither of us is a miracle worker, right?—and I'm not promising you'll go from "#!@X it, I'm picking up" to nothing but up-and-down in one weekend. But I do believe that I can show you the way to

nail the "up" half of the situation close to 95 percent of the time, as in "up and *on*."

Settle for that for now?

So let's start with two easy but ironclad rules:

Rule 1: Don't hit the ball.

Rule 2: There is no Rule 2.

I know, I know. You already know that on bunker shots you're supposed to hit the sand, not the ball. You've read that a million times in the golf magazines and in the pile of instruction books gathering dust on your bookshelf. But four out of five times you find a bunker, you take a big old full swing like you're supposed to, only the clubface of your sand wedge clips the ball and you skull that sucker like a bullet right over the green into who knows what kind of trouble way on the other side.

Sound familiar?

And on the fifth time, you're so dead afraid of doing what you did the other four times that you stop your swing at the very last second and bury your club behind the ball halfway up the hosel. And your ball? It just sits there in the sand looking back up at you, maybe giving you a little wink.

Okay, maybe it's not that bad. Hell, if it was, I figure you'd have given up the game by now. I know I would have.

But if your handicap is anywhere north of 15—that is, if

you have trouble cracking that 90 barrier and playing consistent bogey golf—then I'm guessing you throw up one of those butt-ugly sand shots every so often. And if you have trouble breaking 100 and playing consistent double-digit golf, I *know* you do it a lot.

The good news is that I believe I can fix you right up with one piece of friendly advice: Don't be picky.

That's what's happening when the face of your sand wedge makes contact—*any* contact—with the ball. Subconsciously, you're trying to *pick* the ball out of the sand.

That's understandable. On every other shot in golf, the whole point is to try to make solid contact between clubhead and ball. Anything less and you maybe got yourself some kind of bad shot.

But on bunker shots, if there's *any* kind of contact between clubhead and ball, you got yourself a *terrible* shot—no ifs, ands, or buts about it.

So here's how to stop being picky. Next time you're at the practice range, take our your sand wedge and go over to the bunker. Set your feet in an open stance, zero in on a spot in the sand smack in the middle of your feet, open up your clubface, and take a nice, easy, full swing with a high follow-through, making sure you scoop up about a coffee cup full of sand.

Oh, and did I mention that you do this without a ball?

I'm not kidding. Practice taking full-swing sand shots without a ball. Aim at a single grain of sand and try to make

your wedge's face enter the sand *and pass through it* at just that point.

Do that ten times, then ten times again, until it feels natural.

Now put a ball down about two inches in front of the spot you've been aiming at and take another one of those nice, easy, full swings with a high follow-through that you've just mastered.

Didn't I tell you that the bunker shot is the easiest shot in golf?

"That's great, John! So that's all I have to do to get up and down out of the sand?"

Who said anything about getting up and *down*? I was telling you how to get *out and on*. Teach yourself how to get *out and on* nine out of ten times and then we can talk about getting up and down. Distance control is a whole lot trickier. But you got to crawl before you walk. So get yourself into that practice bunker without a ball and learn to crawl.

By the way, I don't recommend you try to teach yourself to play bunker shots the way I did. See, when I was a teenager learning to play golf back in Dardanelle, the Bay Ridge Golf Club didn't have a single bunker. Nope, not a single grain of sand. You may be thinking, *Great! How lucky was that, Big John!* That might be so if Bay Ridge was the *only* golf course I ever planned to play on in my life, but I knew I couldn't count on teaching myself bunker play at the junior

tournaments I went off to play in. Without a bunker game, I wouldn't be in those tournaments long enough to learn anything.

But what Bay Ridge lacked in bunkers it more than made up for in red clay, which the course was built on, and inadequate maintenance, which was all it could afford. That combo meant that there were always patches of clay around just about every green where the grass was all worn away. So every time it rained real hard, I'd go out to the course and practice hitting flop shots out of that gooey, gunky red clay. Let me tell, that was a helluva steep learning curve. But that's the way I learned to get out of sand bunkers, by hitting about a million flop shots out of wet, soft clay.

Because that's all a bunker shot really is when you get right down to it: a flop shot.

(By the way, if you're thinking about driving down to Bay Ridge/The Lion's Den so you can play a round without having to deal with bunkers, I should tell you that we now have plenty of sand traps, so be sure to bring your flop shot along with you.)

Okay, here are the flop-shot basics—sorry, *sand*-shot basics. Follow them to the letter and I guarantee that every time you have a normal lie in normal sand, you'll get out and on 95 percent of the time.

BUNKER BASICS

1 Ball Position: Opposite your left heel.

2 Stance: Wide open to the left of the target line.

3 Hands: Just slightly ahead of the ball.

4 Club Face: Set wide open to the right.

5 Grip: Soft but firm, just like with every other golf shot.

6 Entry Point: Aim to enter the sand about two to three inches behind the ball in normal sand. A little more if the sand is soft, a little less if it's somewhat packed.

7 Backswing: Good rhythm, as always, but take it up only about three-quarters of your normal full backswing, and make it a tad steeper than normal.

8 Forward Swing: Firm and strong. You're not trying to kill it, but you don't want to baby the sucker, either. Remember, you need to plow through about a cupful of sand to get the ball airborne. That means swinging harder than if your ball was sitting up nice in the grass. (But still not as hard as if it was sitting in muddy red clay.)

9 Complete Your Follow-Through: Let me say that again: *Complete . . . Your . . . Follow-Through.* I

want to make totally clear how important completing your follow-through is for the simple reason that if you don't complete your follow-through on a bunker shot, then you're most likely going to have a second chance then and there. There's nothing more likely to leave a bunker shot on the beach about five feet from your feet than a half-assed follow-though.

All the Bunker Basics are important, for sure, but numbers 7 and 8 are especially so because of the typical amateur's mind-set when faced with a bunker shot: fear bordering on flat-out terror of hitting the ball way over the other side of the green.

That would be a perfectly understandable fear if you were hitting the ball off grass with that kind of full swing. But keep in mind two really important things:

1 You're *not* hitting the ball off grass.

2 In fact, you're not even hitting the *ball.*

But remember rule 1: If your clubface *does* make direct contact with the ball in a bunker shot—*if you do hit the ball*—then you *will* knock that baby over the green. Unless you skull it straight into the side of a steep bunker and watch it carom back right at your feet.

There's a lot more to say about bunker play, such as what to do with fried-egg lies, wet sand, fairway bunker shots,

down slope lies, traps with super-steep sides, and so on. (Later, if you'll send me specific questions on sand play to my website, johndaly.com, I'll do my best to answer them.)

But for now, you spend a couple practice sessions mastering Bunker Basics, and I guarantee you're gonna save yourself a couple of shots a round—maybe more, depending on your course. Pretty soon, you'll have gotten over your bunkerphobia.

Unfortunately, there's a whole bunch of other scary things out on the golf course. We'll take 'em as they come.

→18←
Cut Out the Fat

Stop snickering. I'm not talking about what you're think-ing I'm talking about, although I suppose that would be a pretty good idea as well. I'll put it on my to-do list.

What I really mean is "Cut Out the Fat *Hit*" with your short irons.

Maybe you never exactly draped a divot over your ball while trying to put a little extra hammer into a 9-iron. (I've seen that done in pro-ams, and it's really, really funny, only you can't laugh.) But I'm guessing you have hit it fat once or twice—that is, while looking to loft a towering 140-yarder to the green, you've connected with the ground an inch or more behind the ball and squirted a little pop fly to second base.

Here's a two-step drill that should cut the fat out of your short-irons game:

1 Take your stance, then step back about six inches without otherwise altering your alignment and take a full-bore rehearsal swing. Compare where your club-head clips the grass with where your ball is sitting. If it's way behind your ball, move your ball back a little in your stance.

2 Step back up to your ball, which is now positioned just right. As you get ready to start your backswing, beam in hard on the *top* of your ball, not the back of it. You may not even feel it, but this focus adjustment will encourage an ever-so-slight weight shift to your left on address. This, in turn, will help you make a more upright backswing and deliver a clean and lean hit.

And that other kind of fat? Guess you'll just have to wait for *John Daly's Diet and Exercise Book*.

→19←
Follow *Through*, Never *Back*

Sometimes an amateur I'm paired with in a pro-am will look great taking the club back on his tee shot—low and slow. He'll look great at the top—weight on his right, shaft parallel to the ground. He'll look great starting down—right elbow dropping, belly leading the way. He'll even look great at the finish—hands high, belt buckle facing the target.

And his ball? His ball sails up-up-up and right-right-right into the rough, looking for all in the world like a duck diving for cover.

What happened?

Take another look at the finish, only this time look at his feet and legs instead of his arms and hands. See? His weight's on his right leg.

Buddy, I'll say if he asks what he did wrong, there's a reason why they call it follow *through* instead of follow *back*. So remember, on a full-swing shot make sure your weight shifts from right to left and ends up on your front foot. Gimme a High 10 at the finish. Otherwise, all those good-looking things you do in your swing aren't going to amount to a pitcher of warm spit.

Follow *through*, not *back*.

≥20≤
Listen to Your Right Foot

On the backswing, you want to turn your right side away from the ball. You know that. Anybody who's ever swung a golf club knows that. If you didn't turn your right side away from the ball, all you'd be able to do would be to lift the club and chop straight down, like you were hoeing weeds in your garden.

The key word is *turning*.

Now, repeat after me: "Turning your right side and moving your right side are *not* the same thing."

Again: "Turning your right side and moving your right side are *not* the same thing."

The difference is that "turning your right side away from the ball" means turning around a fixed center, your spine, while "moving your right side away from the ball" means swaying laterally.

Sway.

That's one four-letter word that not even I would use.

Are we on the same page? What you must *not* do is *move* your body to the right, as in moving laterally away from the position you established when you addressed the ball, because moving is really swaying, and swaying on your backswing will rob your swing of most of its power, all but

guarantee a downswing and a feeble slice, and probably wreck your marriage.

Think I'm maybe a little over the top here? No, I'm not. But that's where you'll be coming from on your downswing if you sway to the right on your backswing.

Right about now, somebody out there's thinking, *I know my weight's got to shift on the backswing. How the hell am I supposed to see myself so I can know whether I'm swaying?*

You don't have to "see" anything. You can *feel* it.

At address, my weight is distributed 50-50 on my left and right feet. Midway through my backswing, it's more like 25-75. But get this, it's not because I swayed laterally to the right, but because I turned my upper body around my spine.

How do I know this?

Because I can feel the weight on the inside of my right foot.

The *inside*.

If you feel the weight on the outside of your right foot, it means you've swayed laterally rather than turned your right side around your spine. It means your right leg is bowed out to the right rather than straight. It means that in order to get back to the ball on your downswing you're going to have to sway back to the left. And *that* can lead to damned near anything, direction-wise—a big hook, a nasty slice, or even a straight one right down the center of the fairway, all depending on exactly when your weight gets back to its starting point.

The problem is that if your right foot tells you that you're swaying—and if you pay attention, you'll hear it—then it's going to take some hard work on your part to turn that sway into a turn.

I know. I fell into the swaying habit very early in my career when I was trying to build the biggest backswing arc in the history of golf. When things clicked, and I timed the return sway just right, that big swing arc produced big power with just the right amount of draw. But when I swayed too much and got my body ahead of the ball at impact, I launched some mighty long rockets way, way right of where I wanted them to go. Or, if I hung back too much on my right trying to correct it, I'd let lose some big, nasty hooks that still may be bouncing somewhere.

The trouble is, if you hope to play golf for a living, it helps to know where your shots are going more often than not, so I didn't have a lot of choice in the matter. But when I finally decided to eliminate what is, after all, a major swing flaw, it took me a helluva lot of range time to do it. I had to retrain myself not to let my weight get beyond the center of my right foot on the backswing.

Ever try to change an ingrained habit? Let me tell you, it's not easy, and it's not fast. At the end of a practice session, the inside of my right foot, ankle, and calf would be the tiredest parts of my body. At least that was a good sign: It meant I was learning to keep my weight solidly planted on the inside of my right foot during my backswing.

Maybe you don't have such a bad case of the sways. Maybe you never will. But if you're trying to add 20 yards to your full-swing shots by building a bigger swing arc, I have to warn you that you'll be vulnerable to developing one. Don't worry, though—you'll know if it's happening.

Just listen to your right foot.

⟫21⟪
Get a Cart

I f I had my druthers, everybody would be required to ride a car to play golf, every time. PGA Tour players as well. Everybody. I say make carts mandatory.

Me, I'm out there on the course to play golf, not to prove I can walk four miles on a sunny day when the temperature's 90-plus—or on a gray, windy day when it's 40 and falling. When I'm playing with friends back in Arkansas, I always take a cart. Always—good weather and bad.

But my personal preferences aside, the main reason I believe in carts for everybody is that they'll save time. I think

we all probably agree that the worst thing about golf is how long it takes to play. There's nothing worse than a Sunday-afternoon round that takes five, five-and-a-half hours, maybe more, to finish. Besides eating into the cocktail hour, those long rounds just get flat boring after a certain point.

My solution is to get everybody's butt in a cart, and I do mean everybody. As in, "A cart for *every* golfer."

Think about it. You and I are sharing a cart. I hit a weak slice into the garbage about 200 yards on the right. You pull-hook one about 310 yards down the left side into the rough. (Or maybe vice versa.) First we wait for the other guys in our foursome to hit their shots, which end up about as far apart from each other as ours. So then we drive way over to one side of the fairway for me to hit my shot. Then we drive way over to the other side for you to hit your shot. Meanwhile, the other guys are doing the same thing.

And that's the way it goes all day.

Wouldn't it be smarter if each of us had his own cart? Wouldn't it cut a shitload of time off the round? You know it would.

I'm saying four pretty decent golfers could play a round in three hours, maybe a shade less.

How good would that be?

⊹22⊹
"John, Describe Your Pre-Round Practice Drill."

If you're talking about my pre-round practice drill *before a* tournament, then I can't, because I don't have one. See, I never *practice* the day of a tournament. All I do is get ready to play.

My close friends and caddies through the years swear that my pre-tournament drill for a 9:00 tee time goes something like this:

Wake up at 8:00.

Hit McDonald's for a couple of Egg McMuffins and an Extra Large Diet Coke with lots of ice.

Roll into the course parking lot at 8:30.

Sign a few autographs.

Stroke about half a dozen eight-foot putts on the practice green

Tee it up at 9:00 and stripe a 350-yard drive down the left-center of the fairway.

That's a bit of an exaggeration, but not much.
Other guys on the Tour must disagree, because so many of

them spend so much time at the range before and even after a round at a tournament, but to me the only reason to go to the range before going out to play is to loosen up and say hello to some friends, not to practice. I might not even hit a driver on the range before my round, just some wedges to freshen up my rhythm, and I'll try to take that rhythm—the feel of swinging a wedge—with me to the first tee. Along the way, I will stop off at the practice green to stroke some putts, and they will be 8- to 10-footers, because that's the length putt you face over and over during a round to make birdie or save par.

I remember Jack Nicklaus once saying that if he hit a dozen good shots in a row at the range he'd stop right there and head on over to the first tee. He said he didn't want to waste any good shots at the range; he wanted to save them all for when they counted.

I say anything good enough for Jack Nicklaus is good enough for me.

"Okay, What About Your *Post-Round* Practice Drill? You Know, Going to the Range *After* a Round to Work on Some Part of Your Game That Has Given You Trouble All Day?"

Not me. After a round, and especially after a *bad* round, I want to get out of Dodge, pronto. I think I've been to the practice range *after* a tournament round maybe a dozen times in my entire career, and the times I went there were as much to get away from it all as to correct something in my swing. It works best for me to leave it at the course and start the next day fresh.

My view is that a tournament is for playing, and that I'm going to do my practicing somewhere else.

A lot of the guys on the Tour don't agree with that. You'll always see a bunch of them head straight for the range after a round, whether they played good or bad, to bang balls trying to fix something that's broke.

But remember, I'm talking here about "Golf My Own Damn Way." And my own damn way is to keep prepping to play and practice separate.

→24←
Don't Get "Pulled" Back In

Say you're mostly straight off the tee. It's the best part of your game. Your putter's shaky, and your sand game sucks, but you can pretty much always count on being out there in the middle of the fairway for your second shot.

Except when you can't.

For no reason, and without warning, you find yourself pulling everything left off the tee. Not hooking. Pulling. What the hell's going on here? This is a big match, one I've been thinking about all week, and suddenly I can't stay out of the damned left rough.

Relax.

Aliens haven't inhabited your body. Your swing hasn't deserted you. You haven't forgotten how to do what you do best on the golf course.

Probably what's happened—and here I'm just guessing, because I'm not your coach—is you're pulling the ball left because of all that worrying you've been doing all week. You've psyched yourself up so much about this match that you're tense and keyed up. As a result, you're unconsciously trying to throttle your driver with your right hand. That's causing you to hang on and keep the clubhead from working through the ball.

The fix is simple: Relax your right-hand grip so that your left hand and arm can do their job with having to fight your right side.

Classic *Shmashic*!

"John, how come you take your drive so far back on your backswing? Don't you know that the classic position for the shaft at the top of the backswing is parallel to the ground?"

I heard that or some version of it as many times while I was growing up as you've made double bogey. Seriously, grownups who couldn't hit a bull's butt with a bass fiddle were always pulling me aside and saying something like, "Son, if you ever want to amount to anything in golf you've got to stop going past parallel at the top. That's the classic position."

What's that you say? You've noticed that I *still* go a little past the "classic" position, "a little past parallel" on my backswing? Hell, no, I most certainly do not. That's just not true. I've looked at videos of my damned swing, and I don't go "a little past parallel" on my backswing. I go *way* past parallel. Always have, always will.

And your point?

Sorry, I didn't mean to get testy there. It's just that even though I've had a pretty good career on the PGA Tour and people have long since stopped saying anything about going past parallel to my face, I know that every instruction book writer, every so-called swing guru, and every expert teacher out there will agree on one thing: "Don't go trying to copy John Daly's swing, people. Stick with the classic swing model in which the backswing ends with the club shaft parallel to the ground."

Well, here's what I say: Who says?

Who says that parallel is the classic position? I know, I know—*everybody* says it, but *why*? Who was the *first* guy to say that if your club goes past parallel on your backswing, you're breaking, like, the First Commandment of golf? I'd like to meet up with that fellow in the finals of a long drive contest. Know what? I bet that same guy also used to go around saying, "There's only one way to skin a cat."

Now, as to that business about not "trying to copy John Daly's swing," I'm cool with that. Personally, I don't really believe in copying anything that anybody does, at least not exactly. Okay, I do have to admit that I tried to copycat Jack

Nicklaus when I was learning to play golf. But you know how well that worked out: I've won two majors; Jack won eighteen.

You can borrow, and you can steal, but don't copy—that's my tip for today. Take a little from here, a little from there, a little from everywhere. Then make it all your own. Fiddle with things until you get something that works for you. It has to be a natural movement for you or it won't hold up when it counts.

Anyway, it would be well-nigh impossible for you to copy my backswing, because you don't have my genes and training. I'm talking here about upper-body flexibility. Frankly, I don't know anybody on the Tour who has more upper-body flexibility than I do, and that includes Tiger and Vijay and the other guys who really, really work at it.

I've got to believe that a big part my ability to take a club back as far as I do and not lose control of it (or give myself a hernia somewhere along the way) is a matter of genes.

But another big part of my upper-body flexibility comes from all the time I spent swinging the golf clubs my dad gave me when I was six years old. They were full-size men's clubs—Jack Nicklaus Golden Bears, as a matter of fact—and they were *way* too heavy and too long for a six-year-old. They'd been my father's clubs, but he didn't play much, and he gave them to me because I guess he figured he could always borrow them if he did want to go out.

Kids' clubs would have been much easier to learn to play golf with, of course, but we didn't have the kind of money

for things like that. "He'll grow into them if he likes the game," Dad used to say. "And if he doesn't, he'll just put 'em away and forget 'em."

I guess Dad was right.

(Somewhere along the way, though, I did put them away, only I don't remember where. They're *somewhere*. I didn't just throw them away. They meant an awful lot to me, and I pray that they'll turn up someday. I know I'll never forget them.)

Anyway, what those Jack Nicklaus clubs did was to train my body from an early age to be able to make the big old *unclassic* backswing I have today. Hell, that was the only kind of swing I could make. I couldn't have stopped that big old driver at parallel if I'd wanted to, even if someone had told me about "parallel at the top" being classic and all and that I'd never amount to anything in golf if I didn't swing it that way. And the irons—they were even worse! At first, when I was really little, the clubhead would hit the ground all the way around behind my left foot, and it was a long time before I hit anything like a decent shot.

But what I was developing—and of course I had no sense of this at the time—was a whole bunch of flexibility in my torso, my upper back, and my hips. And I was growing accustomed to the feeling of those big old heavy clubs pulling my upper body up and around and back—an image that you ought to keep in mind: the club pulling your body up and around and back—so that it became second nature to me.

To me, a big, long, way-past-parallel "unclassic" swing

became my natural swing. I'd feel like a pure idiot now if I was to try to take a full swing and stop the club shaft parallel to the ground at the top. I'd probably rupture something and have to give up the game altogether.

Thanks, Mom.

Thanks, Dad.

Thanks, Jack.

"John, What Golf Instructional Books Do You Recommend for People Who Want to Learn the Game?"

Yan mean besides the one you're holding in your hands?

Well, I learned to play golf from Jack Nicklaus's lessons in *Golf Digest* when I was a teenager. They had cartoons showing how to grip the club, how to take the club back—everything. They were perfect. They touched on all aspects of the game. How to hit a cut—take the club back a little outside, and bring it in on the downswing. How to hit a draw—take it back a little inside, and roll your hands over a touch on the downswing. It was just all so easy to follow. And they were cartoons!

Like everybody else trying to learn the game back when I was a kid, I sort of flipped through Ben Hogan's book *Five Lessons*, the famous one with the black-and-white line drawings. It had already been around awhile then. I remember a couple of the drawings of Hogan in what looked like underwear. I think they were trying to show the position of his legs at address or something. Anyway, I remember thinking that was pretty weird. But I didn't really, you know, actually read the book all the way through.

Other than that, I can't say that I've looked at enough golf instructional books to make a recommendation. I know that

guys like Hank Haney and Butch Harmon and Jim Flick and Dave Pelz and David Ledbetter have books that a lot of people swear by. But I didn't even read Jack Nicklaus's *Golf My Way* all the way through. Remember, I'd already read his lessons in *Golf Digest*.

Oh, and I did look through *Harvey Penick's Little Red Book*, the book that everybody was talking about back in the 1990s. But that wasn't really an instruction book, as I recall. Very little technique stuff. It was more a book of stories and sayings about golf.

I remember somebody gave it to me and pointed out that Mr. Penick had something nice to say about me. So naturally I looked. And sure enough, he did. He said that I was athletic and could probably have played other sports; I took that as a real compliment. And he said that people would probably try to change my long, over-the-line swing, but that he wouldn't. I appreciated that, because all my life people *had* been trying to alter my swing.

Anyway, I have to confess I have a problem with the idea of trying to learn the game *from scratch* from a golf instruction book. If you play some, and want to get better, then sure, I think a good instruction book could help. I especially hope *this* one does.

But if you've never touched a club (or only played a few times) and want to really learn the game from the ground up, I strongly recommend that you watch as many good players as you can, and that you take lessons on the basics from a teaching pro before you start reading golf books. If you

don't know a little about what you're trying to do in the first place, trying to translate words on a page to physical movements on a golf course has got to be next to impossible.

This book talks about *some* of the basics, but it doesn't *show* you how to do them. (No cartoons!) What I'll be saying here is intended for people who already play the game. Not as well as they want to and think they can, but they already play. The average American golfer doesn't break 100 if he counts every stroke according to the Rules of Golf. And this book is most definitely aimed primarily at the average golfer, not the rank beginner.

So if you're in that last category, thanks for buying my book, but I suggest you put it on your bookshelf until you've taken yourself some lessons.

→27←
List of Books of Any Kind
That I Have Read Cover to Cover Since
The Grapes of Wrath in High School

N^{ext question?}

Next question?

"What Do You Think About Hybrids, John?"

It depends. If you're asking about hybrid cars, the ones that run on electricity and gas, then you're asking the wrong guy. I mostly drive to and from work in my big old bus. But if you're asking about hybrid golf clubs, let me tell you that I think they're just about the greatest gift to the amateur golfer since the mulligan.

Good for pros, too. I use one. So do a lot of guys on the Tour. Mine is a Taylor Made R7 Draw Rescue, which is somewhere between a 1- and 2-iron. I hit mine about 250 to 260 yards. It's a whole bunch easier to hit out of the rough than a long iron. It's got a permanent home in my bag.

Most amateurs have the most trouble with their medium and long irons, say from 5 through 3 or 2. There's a hybrid that you can sub for each of those, and I think you'll find them a whole lot easier to hit. Go to your pro shop and get a loaner that you can try down at the range. I think you'll see that you have a lot more confidence once you have a hybrid in your hands, and confidence is the beginning of all good golf shots.

"What Style of Putter Do You Recommend, John?"

Sorry, partner, you're on your own on that one. I wouldn't even know where to start, considering that there are more putters out there than you've had hot dinners. Seriously, there's gotta be at least one different make, style, and shape of putter for every golfer on the face of the earth.

You're got your blades, your mallets, your offsets, your insets, and your milled putters. And, of course, from time to time you've got your L-wedge putter or your 3-wood putter on those occasions when your regular putter got all bent up out of shape when you tried to chop down a tree with it.

The one that's best *for* you is the one that feels best *to* you, because putting is about 99 percent feel and 1 percent everything else.

Most Tour players would sooner give up their left little toe than their favorite putter. That's their money club, the difference between spending Sundays chasing six-figure purses and cleaning out the garage. They'd a hell of a lot rather lose the keys to their new Lexus than their putter.

Oh, yeah, now and again a pro will try to teach his putter to swim or test the strength of its shaft over his knee. Even I've been know to "misplace" a putter in the woods from time to time. Hell, I've thrown them, drowned them,

snapped them, and given them away—anything to get one that's turned on me out of my sight forever.

Tough love, I call it.

Over the years, I've used everything from the old Wilson 8802 to the Anser to the Ping Pal series to the Bullseye. Right now, I'm getting familiar with four different Maxfli putters right now, trying to figure out which one I like best.

The Maxfli putters I'm working with all have milled faces—that is, striations that help give the ball overspin, which you've got to have to keep your putt on line. Over the years, I've decided that works best for me. A lot of guys on the Tour prefer inset putters. Still others like . . . well, you see where I'm going here.

A putter's like a good woman. Once you find yourself one, hang on to it, even if it talks back to you ever so often, because you never know what fresh hell you're in for if you trade it in for a new model. Going out and buying a new putter just because you 3-putted three times on the back 9 last Sunday probably won't get at the root cause of your putting problems. To do that, you're probably going to have to take a long, hard look in the bathroom mirror.

Funny, but I betcha that if there were only 4-putter models to pick from, people would putt better. As it is, you've got much too much temptation to change just for change's sake. My recommendation on which putter's right for you is that you find *one* putter that *feels* right to you and give it a fair trial before you even consider trading it in on a different model.

If you push me, though, I will say there is one style of putter that I would discourage you from trying—the long putter. Something about pulling out a "putter" that's longer than my driver, wedging it under my chin, and "putting" the damned ball . . . well, it gives me the willies. No disrespect to the guys on the Tour who use the long putter, but it pretty much advertises to the world that you've got the yips. Even worse, it makes you look like a dork and should be illegal.

So don't let me catch you using the long putter—unless, of course, it feels *right* to you. After all, that's the name of the game in picking a putter.

Who knows, one of these years you might even see me two-handing one of those long babies.

"John, Please Tell Me How to Hit a Wind-Cheater."

No way I'm going to do that, because there's no way *any-body* is going to cheat the wind. The wind wants something, it gets it, whether it's a golf ball in Scotland or the roof of a house in West Texas. Instead, I'm going to tell you how to let the wind be your friend.

"Let the wind be your friend."

I first heard that from Jack Nicklaus when we were playing a practice round at the British Open one year, and later from Fuzzy Zoeller And let me tell you, when either of those guys says something about golf, anybody with any sense at

all ought to listen. (Not that I always did, mind you, but I *ought* to have.)

How you do it, how you let the wind be your friend, is pretty obvious at least three-quarters of the time. Let's assume a 20-mph wind—a pretty stiff one—from four different perspectives.

At Your Back: This is the easy one, of course. For me, if I've got a 20-mph wind at my back and 200 yards to the green, I'll just step down from a 5-iron to a 7 or even an 8, put my usual swing on it, and watch that baby fly. Same for you, with the club selection probably being a little different. Remember, though, that wind will also affect direction, so be particularly careful in taking aim and setting up.

Left to Right: Here you want to aim enough left so that the friendly old wind will blow your ball right, the way I did over and over from the tee at the Road Hole in 1995 when I won the British Open. (Thank you, Jack.) The tough part, of course, is figuring out *how far* left to aim. My only advice there is to give the wind the benefit of the doubt.

Right to Left: Vice versa.

In Your Face: The natural tendency is to try to flat-out kill the ball. Really hammer the mother and show the wind who's boss. Uh-uh. If I've got 150 yards to

the green and no wind to speak of, I'll hit a full 9-iron. But if I'm hitting into a 20-mph wind, I'll step up to a 7-iron and use a *three-quarters* swing. That's right: a three-quarters swing. For you, it's maybe going from a 7-iron to a 5-iron, but the idea's the same: hit a lower, more controlled shot.

Just remember: Whatever you do, don't try to overpower the wind when hitting directly into it. The wind's always going to win.

"What Are Your
Top 5 Favorite Courses?"

One of the great things about being a pro golfer is getting to play great courses all over the world. I've played on six of the seven continents, and I'm pretty sure the PGA Tour will have us teeing it up in Antarctica once Pete Dye finishes building his new course down there.

Naturally, fans are always asking me what my favorite courses are around the world. Maybe they're thinking about going on a golf vacation. Maybe they think I'll come up with some weird, exotic place they've never heard of, somewhere in China or Africa.

First, let me tell you that I always steer clear of recommending the great private clubs that you'll never be able to get on. Places like Shinnecock and Winged Foot and Oakmont and all those other swank, really exclusive places that the USGA almost always picks for the U.S. Open. I mean, they're really great courses and all, but they're off-limits to all but a tiny, tiny fraction of the 15 or so million people that the National Golf Foundation calls "core golfers." (I think they mean folks who've been stung to the core by the golf bug.) Guys like you, I'm guessing.

Frankly, I like it a lot better when the USGA takes the Open to a public track, somewhere like the Bethpage Black

course in New York or Pinehurst Number 2 in North Carolina or Pebble Beach, where Tiger won in 2000 and Tom Watson in 1992, and Tom Watson in 1982 with that great chip on 17 on Sunday that they're still showing on TV every year at Open time. You might have to take out a second mortgage to pay the greens fee at Pebble, but at least you get on if you have a mind to.

But I'm kinda stalling, because people who ask me aren't just looking for some names of good courses: They could go to *Golf Digest* or *Golf* for that. What they really want to know is what my personal favorite golf courses are.

Okay, here are my Top 5.

NUMBER 1: THE LIONS DEN GOLF CLUB (DARDANELLE, ARKANSAS)

If you read my first book, you won't be surprised to find the Lions Den topping my list of favorite tracks. (And if you didn't read it, maybe you ought to put this baby down and run down to the mall and buy yourself a copy. It's called *My Life In and Out of the Rough.*) See, I practically grew up at the Lions Den back when I was a teenager and it was called Bay Ridge Country Club. But don't let the name "Country Club" fool you, by the way; it was actually a semiprivate club in those days, with affordable greens fees. If it had been a real country club where you had to get on a waiting list for membership and have a sponsor and pay a fortune to get in,

I might never have become a golfer, because my family sure as hell couldn't have afforded anything like that.

And now it's mine.

Yep, I bought it in 2005, and recently reopened it after renovating the clubhouse, redoing the greens, building a new maintenance shed, adding some length, and in general sprucing it up.

The Lions Den sits in a beautiful setting in a beautiful part of Arkansas, and it's well maintained. Now it's got some length: 6,730 yards from the Black tees and 7,208 from the Daly tees. But it's got three other sets of tees at 6,310; 5,454; and 4,814, so golfers of all ages and skill levels can feel comfortable. Mainly it's just a hell of a lot of fun to play, which is what golf ought to be. Oh, and it's still semiprivate, with the greens fee soaring all the way to 35 bucks on weekends. C'mon down!

Best of all, the people there are nice, everybody plays fast, and nobody gets a hair up their ass if I close off a hole now and then to practice.

Plus my mother's spirit lives there.

When I die, it's where I'm going to be buried.

NUMBER 2: THE OLD COURSE
(ST. ANDREWS, SCOTLAND)

No-brainer Number 1.

NUMBER 3: AUGUSTA NATIONAL GOLF CLUB
(AUGUSTA, GEORGIA)

No-brainer Number 2.

NUMBER 4: MUIRFIELD
(DUBLIN, OHIO)

The official name is Muirfield Village Golf Club, and, yes, it's private, so you may have a hard time talking your way on to it. But it's the first course Jack Nicklaus ever designed, and he's been my hero since I first learned which end of the golf club to swing, and it's a great track, and it just feels so doggone special to go there and play in his tournament, the Memorial, that I'm listing it here as one of my Top 5 favorites because it would be just flat wrong not to.

So shoot me.

NUMBER 5: THUNDERING WATERS GOLF CLUB
(NIAGARA FALLS, CANADA)

Okay, maybe I'm just a little prejudiced, but I can tell you for a fact that Thundering Waters at Niagara Falls—the first-ever John Daly Signature Course—is one of the most gorgeous golf courses on the face of the earth. It's surrounded by these great, old-growth trees, and from any point on the

course, you can always hear the roar of the falls. It's also drop-dead beautiful, especially in late summer and early fall, when the leaves change.

It's also pretty long, as you probably guessed since I was the fellow who designed it. Long as in 6,730 yards from the Black tees—and 7,208 yards from the Daly tees. (From the tips, the longest hole plays a full 637 yards. It's a par 5.) But there are three other sets of tees, at 6,310 yards; 5,454; and 4,814, so nobody's gonna get beaten up too bad.

For the big opening celebration in August 2005, the plan was for me to become the first person ever to drive a golf ball over the Horseshoe Falls, a 342-yard carry. That was the plan. But the air's heavy because of all that mist, and . . . well, I came up short on my first drive.

And on my 19 mulligans.

⋆32⋆
. . . And One More

Thinking about it, I don't guess it's altogether fair to list the first course I designed as one of my Top 5 favorites, even if it is. Sounds like bragging, or hustling business, or something. So I'm going to give you another all-time favorite course. I'm calling it Number 6 on my Top 5 list, but you can flip-flop it with Thundering Waters if you want to.

NUMBER 6: TORREY PINES
(SAN DIEGO, CALIFORNIA)

Two terrific tracks (especially the South Course), both open to the public.

"John, What's Your Favorite Par 5, Your Favorite Par 4, and Your Favorite Par 3 Among All the Golf Holes on All the Golf Courses You've Ever Played?"

Funny, people ask me that all the time—I guess because they know I play all over the world, and they think that I'm going to come up with some 700-yard par 5 in China or someplace. But I guess I disappoint them a little because the first two of my picks won't come as big surprises.

THE PAR 5

No doubt about it, the 13th at Augusta National. It's the greatest risk-reward par 5 that I personally have ever seen, anywhere, in big part because so much can be on the line on Sunday afternoon. If you're riding a big lead, you can lay up, but you're hardly ever riding a big lead on Sunday afternoon at the Masters. You've got to bend your drive long and a little left to set up your second shot, and you've got to be doggone careful on the second shot because of Rae's Creek in front and the configuration of the green itself. You can make the green but put it too far back on the right when the pin's up front and you're in serious three-putt

territory. But it's reachable to just about all the guys on the Tour if they nail the drive, which is why it's so exciting for the fans watching the Masters on TV on the weekend.

THE PAR 4

That's a no-brainer for me, because it has such personal meaning—the Road Hole at St. Andrews. You've got the wind blowing in off the water—really howling, usually. You've got that tall grass all the way down the left side. You've got the road and the stone wall behind if you fly the green, which is easy to do if the wind catches your ball.

And you've got the Road Hole bunker, which is only the toughest damned bunker to get out of on the face of the earth. You know how you're always hearing people who know golf saying the bunker shot is the easiest shot in the game? Well, the one exception to that generally true statement is a shot from the Road Hole bunker, which is the *hardest* shot in golf.

THE PAR 3

That's easy too. See, I hate *all* fucking par 3s.

"Say *what*?"

Okay, maybe I ought to elaborate on that a little: I . . . hate . . . *all* . . . par 3s.

My deal is that I don't like par 3's as a general rule because way too often luck plays way too big a factor.

The main reason is that your ball flight is too often under the control of something that you're pretty much helpless to do anything about: the wind. And on a par 3, you don't have a second (or third) shot to make amends. You can strike a perfect ball on a par 3, and if the wind is nasty and gusty that day, it could blow that perfectly struck ball off line and just about anywhere.

And there's nothing you can do about it because you're obligated to hit a lofted shot, and that turns control of what happens to the ball over to the wind. On a par 4 or par 5 on a windy day, you have at least two or three shots where you can make adjustments in club selection, setup, and swing. That takes skill and experience, and the better you are, the better the outcome, and that's the way I think it ought to be on every hole.

But on a par 3, you have a crack at making a good shot to the green, and it has to be a lofted shot, and if a gust catches even a *perfectly struck shot*, you're shit out of luck.

The worst par 3, bar none, on the face of the earth—at least on the part of the earth that I've played on—is, without a doubt in my mind, the 17th hole at the TPC Sawgrass in Ponte Vedra, Florida.

You know it as the Island Green Hole.

We pros know it as the $#@%X*# Piece of %&@$! Hole.

Let me tell you why.

Here we are, playing for the Tour Championship—*our* championship—and you're high on the leaderboard with a shot at winning over a guy who's already finished his round when you roll into the 71st hole on Sunday afternoon—the 71st hole of what to us is a near-major, with a lot of money and endorsements and prestige going to the winner. All you've got to do is par in and you've got yourself a big win. You're a deadly short-iron player and a good putter. You've made par-birdie-par on 17 this week.

Things are looking pretty doggone good for you, right?

But this afternoon the wind's come up, and it's gusty, and you stand there on the tee box a good long time trying to figure out which club to pull. Finally, after talking it over with your caddy, who knows your swing better than anyone else, you pull a stick out of his bag.

You thinks it's the right club. Your caddy knows it's the right club. And the guys sitting up in the TV booth are telling each other that they believe it's the right club.

Guess what? *It is the right club.*

Next, after calculating the distance and direction and factoring in the wind as best he can, you—the guy with the right club in his hands—put a perfect swing on it, you strike the ball perfectly, you heart pumps as your ball takes off in a perfect arc dead at the pin, and then you stand there help-

lessly as a gust of wind knocks it straight down three feet short of where you wanted it to land, and the sonofabitch spins back and . . . you know what happens next.

Splash!

Bullshit!

All of a sudden, a cinch par, probable birdie, turns into a double bogey—you're so pissed off at Pete Dye that you 2-putt—and just like that, you're finished. Done. History. (Nice par on 18, pal.)

Okay, maybe I'm getting a little crazy here, but that's the way I feel.

The best par 3 in the world? In my book, there isn't one.

I hate 'em all.

Always Play Barkies

If a game's worth playing, it's worth betting on. That's why a $10 Nassau with automatic presses ought to be as important a part of your regular Saturday-morning golf game as your driver. Hell, I'm pretty sure I'm preaching to the choir on this one, but I want to make sure. Just don't take

more than 30 minutes working out the strokes or you'll lose your tee time!

I'm guessing you play Greensies—closest to the pin on par 3s. (But remember, you got to make the birdie putt to win the green.)

Most people also play Sandies—up and down out of the sand to make par.

Me and my buddies at the Lion's Den in Dardanelle play Skins, Fairways Hit, Automatic One-Downers, just about anything to get extra bets going. The whole idea is to have fun, keep your attention, not make money. This is friendly betting, not serious gambling. Believe me, there's a big difference. I know.

Let me suggest just a few alterations to these old favorites, alterations based on skill levels. If all four of you are double-digit-handicappers and par is not exactly a routine score, then change it so up and down out of the bunker to make *bogey* earns a Sandie, and remove the birdie requirement for the Greensie. The guy closest to the pin on par 3 can take two putts (but no more!) and still win. And if one guy in the group is a single-digit player, adjust the rules so that he has to get par for a Sandie and birdie for a Greensie, while the rest of you can make bogey and par for a win.

The whole idea of these kinds of wacko bets, as far as I'm concerned, is not to see money go back and forth, but to watch the reactions of the guys you're playing with. That's one reason I *insist* that winners get paid on the spot. Trust

me, it's more fun that way. Hey, you hit three clowns at a $10 slot in Vegas, they don't make you wait until the end of the evening to get your money!

And while I'm talking about wacko bets, let me tell you about the Barkie.

Never heard of it? Neither had I until once when I played in a pro-am with three crazy guys named Ziggy, Lennie, and Sudden Pete. None of them could play golf worth a shit, but the fun they had on the golf course had to be way beyond the legal limit.

A Barkie, Ziggy explained to me, is when you hit a tree and *still* make par. That is, you hook or slice a wild drive, get an amazingly lucky bounce, and somehow manage to get on and in for par. It doesn't happen all that often—guys who hit trees are usually looking at a snowman, or worse. So maybe you ought to make the payoff $50, to reward the lucky bastard who does it and to really piss off his playing partners.

So if you make par—or even bogey, if you do a skill-level adjustment—after hitting a tree, give yourself a Barkie.

"Cameras and Cell Phones at Tournaments—Your Thoughts?"

Now you're just trying to piss me off.

At the Honda Classic in the early part of the 2007 PGA Tour season, I'd just started my downswing when this woman's camera clicked while she was fixin' to take my picture. Stopped me in my tracks. Jamming on the brakes, I separated a couple of ribs and my shoulder.

The ribs were okay pretty quick. The doctor only had to pop them back in once. The shoulder, though, he had to pop in three times, and it was sore all year.

Tells you something about the speed and power of the golf swing, doesn't it? The doc told me, "You'd be better off in a damn car wreck doing 80 miles an hour." Your club speed is 130 or 135 miles an hour, and you try to stop? Hell, you're bound to screw something up.

It also tells you how thoughtless people can be. That particular click of the camera cost me three months on the Tour and affected the way I played the rest of the season.

I think the Tour ought to ban *all* cell phones and cameras from the course when a tournament's going. That includes pro-ams and practice rounds and the range. Not just the fans, but players and caddies and everybody.

Cell phones and cameras have got to go.

I don't care if it means doing strip searches at the gates.

"JD, How Low Can You Go? What Was the Best Score You *Ever* Shot? Not in a Tournament, but with Your Buddies Somewhere—No Pressure, but No Mulligans?"

My personal lowest, counting 'em all? A 57. At Bay Ridge in Dardanelle. That would be 15 under. Shot it twice, actually. But that's when the course was a whole lot easier, with really soft greens. It was really short back then; I could pretty much drive all the par 4s. The par 5s were like driver-sand wedge for me.

Since I took it over, Bay Ridge is a little harder. I firmed up the greens, lengthened a few holes where I could. And I changed the name to the Lions Den Golf Club.

Some ways I kinda regret doing it, though. It was pretty sweet to look down at your scorecard and see all those 3s.

→37←
Go Ahead—Pull Out Your Puttchipper

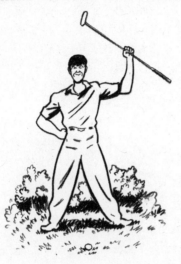

No, that is *not* what you're maybe thinking it is . . .
(I tell you, some people have dirty minds!)

What I'm talking about is a club you might want to consider using for a certain kind of shot when the conditions are right.

Let's say you're on the fairway just off the green, maybe 25 to 30 feet from the apron and another 15 to 20 feet from the hole, with a good lie. What club should you use?

Me, I'd use my L-wedge. A lot of pros these days would, too. But we're pros. You're not. So what's it gonna be?

Before you answer, let me give a little pop quiz to the average golfers out there: Which of the 14 clubs in your bag do you consistently make solid, center-of-the-clubface contact with most often? Think about it for a second.

What's that? You said driver? Well, good for you, because if you make solid, center-of-the-clubface contact with your driver more often than with any other club in your bag it, then it's a lead-pipe cinch that you're way better than average.

Let's try again. Let's say you're an average golfer. What club should you consider using from the fairway up to 20 feet or so off the green *if conditions are right* and if you're not comfortable with employing an L-wedge for that job? Still not sure?

Let me give you a hint. It's a club you use *at least* 30 to 40 times a round already.

That's right. Your putter.

Putting from just off the green instead of chipping will, I guarantee it, shave a couple of strokes off the score of most amateurs. And get this—using a putter for that kind of chip shot will help double-digit handicappers even more than it will better golfers.

The reason that putter's a good choice for most amateurs in this sort of situation is that a lot less can go wrong. You're less likely to chunk it. You're less likely to blade it. And you're less likely to hit it way long or way short.

Plus most amateurs are way *more* likely to keep it on line straight toward the hole with the putter because—you guessed it—they're likely to make more solid, center-of-the-clubface contact.

Remember that shot by Constantino Rocca from way down in the Valley of Sin at the 18th at St. Andrews that sent the 1995 British Open into a four-hole playoff? I sure as hell do. I was leading the tournament, and he needed a birdie at 18 to tie me. When he stubbed his second shot, I thought for sure I had me that Claret Cup won. Hey, you can't blame me for thinking it was time to start high-fiving people (though I want to make clear that I didn't). I mean, he was 65 feet from the pin. He'd be lucky to get down in two.

Instead, he drained it.

Besides for the fact that I love the eventual outcome that day, of course, the reason that I'm telling this story is that Constantino sank that "chip shot" with his putter.

So the next time you're just off the green, consider using your putter for your "chip."

Notice I said *consider*. Like just about every choice you have to make in life, it depends. It depends on how long the fairway grass is; if it's rained since it was last cut, you might be better off with a lofted club. It depends on whether the hole's cut on a mound, with a big down-slope behind it; speed control's a little tricky when you're moving from fairway to green with a putt, and you don't want to run your ball off the other side. Take into account the lay of the land before making your call.

But *if the conditions are right*, don't be afraid to go a little unconventional when you have a shot from 25 to 30 feet off the green. Putt it.

"Pro-Ams Are a Big Pain in the Butt, Right? You've Got a Tournament to Prepare for, but Instead You've Got to Spend Five to Six Hours Playing Golf with a Bunch of Hackers. You Gotta Hate That."

Look, I know a lot of the guys on the Tour feel that way about pro-ams, even if they won't say so on the record. But I don't. No, I'm dead serious. I know pro-ams are super-important, and I kinda like 'em.

One, a pro-am is another practice round. Tour veterans know the courses we play on year in and year out, but ever so often we'll go to a new track that we don't know; or maybe you haven't played in a particular tournament for a couple of years, and anyway you want to get a feel for the conditions, how the greens are running, that sort of thing.

Two, I can't tell you the number of business deals I've gotten into from meeting people at pro-ams. I'll meet somebody and get invited to a corporate outing, or I'll do a sponsorship thing. Plus there's just the pleasure of meeting new people, talking about stuff, actually having some fun playing a game that becomes all business the very next day. Shit, all the guys on the Tour already see plenty of each other at the office. It's nice to see some new faces once a week.

But mainly what I've always respected about the pro-ams is that they raise a ton of money for a lot of good causes.

I mean, they're for our sponsors, and our sponsors are the ones who're putting out all that money for us. They basically write our mortgage checks. Playing a round of golf with their clients and business associates, and while we're at it raising money for charity? That's the least we can do.

Yeah, it takes a long time, and it's tough when you get to the six-hour mark and you've still got two holes to play, the way it sometimes happens. But it's a lot harder for the amateurs. You know, they don't want to be out there all day. They don't play as much as us, remember. And I'm guessing that by around five hours, any excitement they might have got from teeing off with a real live PGA Tour pro has long since worn off.

Maybe we should play 18 holes or five hours, whichever comes first. Still got three holes to play? Put down two pars and a birdie and let's go to the clubhouse bar and talk about what a hell of a round you had.

I promise you that most of the amateurs I've played with in pro-ams would buy into that in a New York minute.

"In the British Open at St. Andrews in 1995, When You Came to the Road Hole on Sunday and Pulled Driver, Jack Nicklaus said on TV, 'Put It Away, John. Put It Away.' You're Older and Wiser Now. Would You Still Hit Driver?"

Oh, yeah. Absolutely. What people don't understand is that the left rough at about 230 to 270 yards at the Road Hole at the Old Course, which is where I'd most likely have been if I'd hit 3-wood and drawn it too much, was twice as high as it was at 300 to 340, where I figured I'd be if I got too far left with my driver. And I'd be setting up to go down the left side because there's a lot more room. The further you go, the easier your approach to that super-tough green. So I hit driver the first day, made par. And then the second day I hit driver, made par. The third day I hit 1-iron—played it "safe"—and made double. I hit it good, but the wind took it and I ended up in the thick shit. And I said to myself, "Man, I got to hit driver here tomorrow."

Well, on Sunday the wind was blowing 30 to 35 miles an hour. It was going to blow anything you didn't hit hard way right. That would give you a long iron into the green, and you sure as shit don't want to hit a long iron into the Road Hole. And so I did what I thought was going to give me the

best way to win: I pulled out my driver. And I hit it perfect and had a 9-iron in. Two putts, par.

You know, I think that if Jack had been down there instead of up in the booth, he'd have done the same thing I did.

Be Honest with Yourself—
and Save a Couple of Strokes

You slice. Right? You slice. I know you do. If you're an average golfer, way more often than not you slice your tee ball. Bet you a sleeve of Maxfli 100s that you do.

C'mon, might as well own up to it. Nothing to be ashamed of. And you've got plenty of company. I'm saying that, like 70 percent of the millions of golfers with double-digit handicaps in America who play about three times a month, you tend to slice off the tee.

Call it a big old banana. Call it a fade on steroids. Whatever you want to call it, and sometimes that's something not repeatable even by me, nine times out of ten your ball sails right off the tee, right? Or left, if you're a lefty.

(Look, me adding that every time would get old quick. You lefties are just going to have to assume you're in our foursome without me saying it, okay?)

Righty or lefty, when it comes to golf, America is a nation of slicers.

How do I know? You mean besides having somebody checking out the stats with the USGA and polling a bunch of golf teachers? I know it from going on 20 years of playing in pro-ams and at sponsor outings. I know it because it's a dead-solid fact. And so do you.

So how come you won't admit it?

Oh, you'll admit it if I ask you about it *before* a round. And after a round, I don't have to ask and you don't have to tell, because the truth's just been demonstrated to both of us.

But *during* a round, you're in full denial.

That's right, denial, something I've had a little experience with it, so I recognize it. You're like, "What? Me, slice? No way!" And then, it's—*crack!*—"Fore, right!"

No, I can't tell for sure an amateur playing partner is a slicer until I see him make a few swings. But once I've figured that one out, I can tell he's in denial every time he steps up to the tee.

How? His target line tells me.

I see it all the time. A guy with a grooved, lifelong slice is about ready to tee off on the first hole. (Let's call him "you.") You pull out your Big Dog, walk to the smack-dab middle of the tee box, and set up on a target that runs straight down the middle of the fairway.

What's wrong with that, you ask? Nothing, if you have a 50-50 likelihood, based on past experience, of hitting your tee shot 20 yards either side of that bee line down the middle. But if you're 90-10 to hit it somewhere to the right (or far right), you're only giving yourself half a fairway of safe harbor. You're setting yourself up for a tough four hours even before you pull back your club.

What's the solution? In the long run, of course, you've got to fix that slice. Or at least tame it. Remember what Lee

Trevino, who was one of the all-time great faders, once said? Something like, "You can talk to a slice, but a hook won't listen."

Look, there's going to be a lot more later on how to straighten out a slice. I honestly believe I can help you here. But that's going to take a while, and it sure ain't going to happen in the course of this round we're talking about that this guy—you—is about to play.

So until we can fix that damn banana of yours, do these two things:

1 Set up on the far right side of the tee box.

2 Take aim down the left side.

A stopgap measure? You bet your ass. And it'll be a dead giveaway that you think—you pretty much *know*—that you're going to slice. Good. You're no longer in denial. Give yourself a pat on the back.

Better still, you've set yourself up for a tee shot that most likely ends up in the fairway. It might not be all that pretty, and we've still got to get you on a program to get rid of that banana. But for now, you're on the short grass.

And in the worst-case scenario, you set up far right and aim to the left, and you come out with one of your one-in-a-hundred duck hooks, only this time it takes out the windshield of your SUV in the parking lot. No problema.

Take a mulligan.

⇥41⇤
Leave the Big Dog in Your Trunk

I want you to conduct an experiment, but I have to warn you that you're going to think it really sounds weird coming from me, Mr. Grip It and Rip It. Seat belts fastened? Okay, here it comes:

The next round you play, leave your driver in the trunk of your car.

Let me write that again, because I know you're not believing your eyes:

The next round you play, leave your driver in the trunk of your car.

Look, we both know that nothing feels better on a golf course than to really nail a driver dead-solid and see that little white ball soar into the sky like a rocket and come to rest smack dab in the middle of the fairway about 330 yards from where you're still holding your follow-through pose. Okay, maybe it's only 230 yards, or 200, or whatever. You know what I mean.

My question to you is: How often does that happen with your current swing? Let's say you pull driver 14 times for your tee shot during the course of a round. How many times do you end up in the short grass? Be honest. I'm talking most of the time, not just that day two summers ago when you hit every fairway and thought you'd died and gone to heaven.

Ten? You're telling me 10 out of 14 drivers you hit off the tee end up in the fairway a pretty good distance from where you started? Good for you! Skip right on over this tip and move on to the next one.

But if you answer in the single digits—say, 8 of 14, or 6—then I think you ought to give really serious thought to trying my little experiment and use your 3-wood off the tee.

No doubt about it—the driver gives you a huge boost if you hit it right. But there's also no doubt that no club can bite you in the ass harder if you hit it wrong.

I'm not saying abandon your driver forever. I'm confident that some of the tips I'm offering up in here will help you hit it better. But your goal is to cut strokes off your score *now*, right? Not show off the size of your . . . driver.

So just for one round, try teeing off with your 3-wood on every hole where you'd normally hit driver. Sure, you'll sacrifice some distance. But I think you'll gain some perspective on how to score better.

Leave your driver in the trunk.

Where People Play

The National Golf Foundation says there are about 16,000 golf "facilities" in the United States. (I know because somebody looked it up for me.) It defines a "facility" as a place with at least one golf course. All told, per the NGF, that works out to be about 15,000 "18-hole equivalents." (Some of those facilities are 9-holers.)

Do you realize that, playing two rounds a day, 365 days a year, and not factoring in travel time, it would take you about 25 years to play every hole on every golf course in America?

Is this a great country or what?

And by the way, you bet your ass you'd have knocked at least ten strokes off your score by the time you were done.

Of those 15,000 courses (or "18-hole equivalents," if you're a nitpicker), about 11,000 are open to the public. So you could probably finish in, maybe, 19 years without setting a foot on Shinnecock or Augusta National. (That's a pity. They're great tracks.)

Not surprisingly, I guess, the states with the most golf courses are Florida (1,200), California (1,000), and Texas (900). What does surprise me is that Michigan (875) ranks fourth. I thought it snowed its ass off in Michigan in the winter? And New York (850) is fifth.

What the hell ever happened to Arizona?

→43←
The Average Golfer

Only 20 percent of all the golfers in America consistently break 90. Most of you—60 percent, if you're scoring at home, and I sincerely hope you are—shoot between 90 and 119. The *average* score among all American male golfers is 94.3, although I'm guessing that there are 20 million to 25 million mulligans that don't get counted in coming up with that average.

These are true facts. I'm not making them up. They come from to the National Golf Foundation. I had somebody look them up. And I believe them.

The thing is, who really gives a shit whether you're above average, below average, or average average? There's only one question that really matters: *Are you having fun?*

End of test.

Can you do better?

You bet!

A Tip of My Cap

After I won the PGA in 1991, I wrote a book called *Grip It and Rip It: John Daly's Guide to Hitting the Ball Farther Than You Ever Have Before* (HarperCollins, 1992) with John Andrisani.

Actually, "wrote a book" isn't 100 percent accurate. What I did was "talked a book" with John Andrisani. The ideas in *Grip It* were mine; John was responsible for making them make sense.

John was then—and still is—one of the top golf writers in the business. He's written a bunch of books with people like Seve Ballesteros, Sandy Lyle, Chi Chi Rodriguez, Fred Couples, and Butch Harmon, and another bunch on his own. I'd like to thank John once again for translating my notions about how to play this crazy game into passable English.

In working on this book, I went back to *Grip It*, and let me tell you, it's a pretty doggone good book, if I do say so myself. The pictures look a little weird (Who *is* that young stud?), but there are some good tips there. Over the years, I've changed some of my ways of doing things, thrown out a few, and added a few new ones, but if you can find a copy of *Grip It*, grab it. I think it'll help.

I know it helped me frame some of the thoughts, suggestions, and tips you'll find here.

Not So Fast There

You got a 1:30 tee time on Saturday, and you'd think you ought to be able to count on getting back home in plenty of time to take a shower and have a couple of beers before your friends show up at 7:00 for a cookout, right?

In your dreams.

At public courses on a weekend, and at lots of private ones, the five- to five-and-a-half-hour round of golf is the norm. And it's just about as long on the PGA Tour, with the biggest difference being that we're getting paid big bucks to do it.

"I *hate* slow play." Ask a hundred golfers and that's what

you hear, at least a hundred times. Every last one of 'em will tell you the thing he hates more than anything else about the game is slow play.

If you think about it, though, some of them must be lyin' through their teeth. In fact, there must be a bunch of folks out there who actually *love* slow play, or else there wouldn't be so damned much of it.

Fifteen years ago Marc Calcavecchia and I pulled a little stunt that sort of called attention to the problem of slow play, and what did we get for it? We got slapped with fines by the Tour Commissioner at the time, Deane Beman.

It was the final round of the 1992 Players Championship at Ponte Vedra Beach. Me and Cal were way out of the hunt. In fact, as the last two guys on the leaderboard, we were the first two guys off on Sunday morning. We got to the first tee with the same idea: Let's pack it in and get out of Dodge. So we decided to have a little fun—we were going to play as fast as we could. Walk up and hit the ball. No throwing up grass to check the wind, no fretting over which club to pull, no looking at every putt from every point of the compass. Let me tell you, we played *fast*. Finished in a little over two hours. Hell, we could have played 36 in less time than it took the rest of the field to finish 18.

And not only did we have fun, but so did the handful of fans up and out that early to watch us. Once they caught on to what we were doing, they were hoopin' and hollerin' and cheerin' us on.

The only person that didn't get a kick out of it was Deane

Beman. Once he got wind of it, he had his people get in touch with me and Calc and tell us we were going to get fined—and we were—for, I can hear the words still, "conduct unbecoming a member of the PGA Tour."

Bullshit.

Not for one minute were we trying to be disrespectful, not even when we hit our tee shots at the same time. (Hey, there's nothing in the rules that says you can't.) We were trying to have fun. *F-U-N*. And I can tell you for a fact that those fans following us around, they had a helluva lot more fun than if me and Calc had been out there grinding, sweating every three-footer, studying every shot like it was some kind of do-or-die thing. I shot 80-something, Calc shot 80-something, we signed some autographs, and we got out of Dodge.

What's wrong with that?

Look, after all these years, the thing that chaps my butt most of all is that four years before, Greg Norman and Mark O'Meara did the same thing we did at the Nabisco Championship, the last big tournament of the year.

True fact.

Only they announced beforehand they were going to do it, play as fast as they could. They said they were going to "break the record" for the fastest round of golf ever played on the PGA Tour. (What was that record? Hint: There wasn't any.)

Like me and Calc, Greg and Mark were way out of the hunt. Like us, they were the first pairing off in the morning.

Like us, they didn't exactly freeze over their putts or take a lot of time deciding if it was a hard 5 or an easy 4. *Un*like us, they ran to their balls between shots.

People were cheerin' and hollerin' and havin' a great old time, just like they did for me and Calc four years later. Why wouldn't they? Everybody was having fun.

But unlike us, Greg and Mark didn't get fined, or scolded, or made to stay after school, or anything by the commissioner. I can't imagine that Beman was happy. As commissioners go, he was as conservative as they come. I truly believe he'd have preferred it if we had all wore suits in tournaments, like you see in those old pictures back in England.

No way, though, was he going to fine Greg and Mark. After all, they were Greg Norman and Mark O'Meara, marquee players, big names. Me and Calc? We were just a couple of wild hairs who misbehaved and had to be disciplined.

Oh, they completed their round in 84 minutes.

I'm saying that that's one record that'll *never* be broken.

⋙46⋘
My Favorite Teacher

My first ten years or so in golf, I didn't have a teacher. Seeing as how I started swinging a golf club when I was four and got my first set of clubs when I was six, I guess that's not too surprising. By the time I was ten or eleven, I was just about living at the Bay Ridge Golf Club in Dardanelle, Arkansas. Playing 36 holes on a summer day was nothing special. Pretty much the year around, the only thing that kept me off the course was school and lightning.

Then, when I was about fifteen, I met Rick Ross.

Rick grew up there in Dardanelle. Like me, he spent every spare minute at the golf course, but he was six years older, so we had never gotten to know each other. When we did meet in 1980, he was on the golf team at Arkansas Tech, about ten miles up the road in Russellville. That right there made him a hero to me right out of the box.

Anyway, we hit it off, and started playing a lot of golf together. I couldn't even guess how many rounds we played over the next five years. After Rick left Arkansas Tech, he became a golf teacher, but I was really his first student. Today he's director of golf at a club in Hot Springs. We've kind of lost touch over the years, but I still owe him big-time.

We had the teacher-student thing going from the git-go, but mostly it was out on the course, not on the practice

range. We'd play, and he'd talk to me about my swing, about how to make different kinds of shots, about how I ought to be thinking about what I was doing instead of just doing it.

It was always simple, always basic with Rick. Stuff like, "Low and slow on the backswing," and "Start on the right, finish on the left," and "Don't get quick," and "Always finish your backswing."

I know I wouldn't wanted to have been teaching me—I was just this big, headstrong teenager who thought he knew everything about the game of golf. But Rick has a world of patience about him.

I'd say he was born to teach the game of golf.

Keep It Short and Sweet

One thing I know for sure about your golf game is that, most of the time, you're not on the green in regulation. Yeah, I know—that sort of goes without saying. If you *were* on the green in regulation most of the time, then you wouldn't be wasting your time reading some book about how to play bogey golf. You'd be out on the practice green working on your putting stroke, because that would be the only thing left to fix to turn you into a scratch golfer.

No, most of the time you're looking at a shot from just off the green that will get you up and on the short stuff so that you can two-putt and save bogey—or worse. (I'm not going to talk about how bad "worse" sometimes gets. Shit happens, but it doesn't do anybody any good to call attention to it.)

Faced with a shot from just off the green—say, 30 to 50 feet from the hole—the first question you have to answer is the one I hear from just about every amateur I play: "What club should I use?"

Once upon a time, the standard answer to that question was a version of "It depends." Maybe a wedge, maybe a 9-iron, maybe a 7-iron, whatever. That's because all the instruction manuals and most of the teachers wanted you to pick a club with just enough loft to land your ball on the green just beyond the fringe from which point it would run on up to the hole.

Made sense then, makes sense now. But it's not the only way. And I'd like you to try one that I think works better.

A lot of golfers on the PGA Tour today—and I'm one of them—use one club for *all* shots from just off the green and up to 50, maybe even 75 feet from the hole.

The L-wedge.

"Stop right there, John. That's the club I use for a pitch when I want to throw it up high just a short distance, maybe from light rough or whatever. But you were talking about *chip* shots here."

I still am. And what I was saying is that I use my L-wedge for *chip* shots from around the green.

Look, I know a lot of amateurs are scared to use the L-wedge unless their ball is sitting up and they can take a full swing at it. On regular fairway grass, and faced with a short shot, they're afraid they're going to hit it too far. So what happens a lot is that they de-accelerate on the downswing and end up chili-dipping or hitting a line drive to centerfield.

There's a happier ending to that story: The ball goes up nice and soft, lands on the green beyond where it would have with a less lofted club, and runs right up to tap-in range.

Okay, I can't quite guarantee that, but I do think your L-wedge increases the chances of it happening because it simplifies the shot.

For starters, it takes selecting the right club out of the equation.

F-L-E-X Drills

A bout now you're thinking, *I think I must be dreaming—John Daly's going to tell me about some* exercise *routine? Next he's going to tell me that the Earth is flat.* (Not really. Just West Texas.)

Look, it's no big secret that I'm not exactly Mr. Fitness. Some of the guys on the Tour, I gotta believe they spend as much time in the gym as they do on the golf course. More power to them. Me? I feel the same way about working out in a gym as I do about par 3s.

Hey, I tried working out back in the early 1990s, but I got tired of it fast. Every time I worked out I threw up. After a while—a short while—I thought to myself, "I can get drunk

and throw up; I don't need this shit." I mean, you can throw up after an hour's workout, or you can drink for 20 hours before throwing up. Back then, it was an easy choice. Today, I think I get enough exercise walking five or six miles a day.

But upper-body flexibility is absolutely key to making a full, easy, body turn, which in turn is critical to generating a more powerful swing. Problem is, as we get older, we get *less* flexible, and we really have to work at it. Let me just say that there's no such thing as being "too flexible" in golf. So I'm going to throw out a couple of exercises that'll help—provided, of course, that you do them:

TOE REACHES

1 Sit on the floor with your legs stretched out straight in front of you, feet about shoulder width apart.

2 Reach out your arms *s-l-o-w-l-y* toward your left big toe. Try to touch it. If you can't, that's okay. Just go as far as you can and hold the position for a count of five.

3 Now relax and *s-l-o-w-l-y* bring your body back up to starting position, take another count of five, and do it again, this time reaching for your right big toe.

4 Caution: Don't bounce trying to get more distance.

5 Repeat drill four times.

CRUNCH TIME

1. Still on the floor, same position as for toe reaches.

2. Draw your knees up and in as close to your chest as possible. (If you find that something, ah, gets in your way, you might keep that in mind the next time a waitress asks if anybody wants dessert.)

3. Wrap your arms around your knees and pull them up tight against you, head tucked down.

4. Hold for a count of five, then relax and return *s-l-o-w-l-y* to your original position.

5. Repeat drill four times.

TORSO BENDERS

1. Lie on your back, knees pulled up, feet flat on the floor, with arms straight at your sides and palms facedown on the floor.

2. *S-l-o-w-l-y* try to touch your left knee to the floor while keeping your back, shoulders, and palms flat against the floor.

3. Take the stretch as far as it will go and hold for five seconds.

④ Slowly return to original position, rest for a count of five, and then swing your knees in the opposition direction, this time trying to touch your right knee to the floor.

⑤ Repeat drill four times.

⟫49⟪

"What About Running to Get in Shape, John?"

To tell you the truth, the only time I'd ever recommend that you run is if somebody's chasing you. That's always been my policy, and I'm not about to change it now.

→50←
Gain Some Weight

That's right. For dessert, order two Big Macs, two double fries, and a chocolate . . .

C'mon, you know damned well I'm not talking about *that* kind of weight. I'm talking about a little gizmo that I think will help you swing a golf club better.

Normally, I'm not too big on special devices that are supposed to help improve your golf swing. The big golf stores are full of them; so are the ads in the back of all the golf magazines. You know what I'm talking about. Those deals where for only three easy installments of $39.95 you can have as your very own some gizmo that will groove a perfect swing and knock ten strokes off your score.

Bullshit.

But you undoubtedly know that already, right? Even so, I'm guessing that if you've played golf any length of time, you've dropped a few bucks over the years on one gadget or another "guaranteed" (sort of) to turn you into a scratch golfer.

And did any of them help?

I thought not.

There is, however, one (and only one) golfer's aid that I do believe is worth your spending a few bucks on: the weighted club.

The thing probably has some fancy trademarked name, but they're not paying me anything to say nice things about it, so I'm not going to bother having somebody look it up. Anyway, you know what I'm talking about—the one with the shaft that's bent all whomper-jawed, like it had been in a fight with a tree trunk . . . the molded grips to get your V's pointing the right way . . . and the weird looking head that looks like a 2-iron on steroids only with the center of it cut out and the remainder encased in yellow vinyl. Must weigh five times, maybe more, than a standard golf club.

Get the picture?

Well, get the club, because I truly believe that swinging that heavy baby will help build the golf muscles in your arms and shoulders, help groove a good swing path, and help you build up clubhead speed. You can use it in your backyard, in your rec room, just about anywhere, because you're not hitting a ball, you're just swinging a club.

So pitch all your other golf toys. You don't need them cluttering up your garage anymore.

What you do need is to gain a little weight.

→51←
Crank Up the Volume

I love music. Most of it, anyhow. Classic? Not so much? Easy listening? Not on *my* radio. Rap? I like some of it okay; I just don't see how you can call it music. No, I love the big three: country . . . rock . . . blues. Or sometimes, rock, country, and blues. It all depends on my mood. But I can tell you this—I've always got something going on my bus, that's for damned sure.

My favorite artists? Shit, I knew somebody was going to ask that, and I know I'm going to leave out somebody important. But here goes, in what I'm reasonably sure is (more or less) alphabetical order:

Steve Azar

Kenny Chesney

Hootie and the Blowfish

Johnny Lee

Edwin McCain

Pat McGee

Kid Rock

Bob Seger

Lynyrd Skynyrd

George Strait

Hank Williams Jr.

Mark Wills

I love all the great old classic rock groups: the Stones, the Who, the Band, Credence, even the Beatles. Hank Williams Sr., too.

Who'd I leave out? I know I'll hear from 'em, so I might as well apologize now.

Just figure this—the chances of me having some good music going on my bus at any given time are, oh, a little over 100 percent.

My Magic Bus

Professional golf is a road sport. Team sports, you're play-ing home games half the time, relaxing in your own backyard after a game, getting up in your own bed on game day. On the PGA Tour, the only time I get to sleep in my own bed is when the Stanford St. Jude Championship comes to Memphis the first week of June. Let me tell you, that matters a lot.

Especially when you're young, and you're worrying about keeping your Tour card, and you're seeing a new course every week, and you're still trying to figure out how to play this

crazy game, getting a decent night's sleep on Thursday night could mean the difference between playing golf for money on the weekend and watching cartoons Saturday morning before packing up and heading out to the next town. Been there, done that.

Fortunately, I'm at the point in my career where I can rest assured of getting a good night's sleep at every Tour stopover. All I have to do is take the bus. *My* bus.

That's how I've been getting around the last ten years or so. Not long after I won the British Open, I bought my first bus, had it customized with all the creature comforts I could afford at the time, and hit the road.

That big wind that swept the country back then? It was me breathing a sigh of relief at cutting my visits to airports to a bare minimum. See, I hate flying even more than I hate par 3s, and that's saying a mouthful.

What's there to like about air travel? Not getting to the airport two hours before your scheduled takeoff, only to find that your flight's been delayed an hour (or more) because of bad weather. Not finally taking off and hitting some of that bad weather after all, and thinking for sure that this time you've bought the farm. Not the food, that's for damned sure. Not for being able to walk around or take a little detour whenever you damned well please. ("Passengers must remain in their seats with their seat belts buckled so long as the Fasten Seat Belts sign is illuminated. This means *you*, Mr. Daly.")

Much as I love the British Open, I'd love it even more if I could figure out how to drive to it. Wouldn't matter if part of the trip would have to be on the wrong side of the road.

Growing up in the South, I've always been big into cars and driving. My first car was a 200SX with 130,000 miles on it. I also had a Chevy van with 150,000 miles on it. My first bus had a sweet license plate: PGA 91. Called it "The Lion." People used to honk when they saw the plate or the big Lion logo on the sides. I loved that baby.

My new bus is a beauty. Got it last fall. It's a 2007 Featherline H3-45, the "Vantare" model. Strictly top-of-the-line. It's got everything: king-size bed, washer-dryer, kitchen, dining table, two 46-inch plasma TVs (one at either end) plus a 32-inch screen in the galley, sofas that fold out (it sleeps an additional six people), mirrored ceilings, marble floors, a big fold-out grill with an awning when I want to cook out, and all kinds of custom details inside (like glass-inlaid Lion logos in the shower).

Motor-wise, it's got a 515 HP Twin Turbo engine, with a six-speed transmission. Cruising speed, at least when I'm behind the wheel and we're on an interstate, is 80 to 85. It's got a 206-gallon gasoline tank and gets about 7 miles per gallon. On a full tank, I can go 1,000 to 1,400 miles between fill-ups.

I do most of the driving. And while driving, I've been pulled over a few times by highway cops. But you know what? I've never gotten a ticket in either of my two buses.

Of course I have signed a few autographs along the way. Maybe handed out a sleeve or two of golf balls. (Hey, state troopers play golf, too.)

In case you were wondering, I think I'm a damned good driver. Call me on my cell—no, I am *not* giving you my number—and the music you get before I come on (or you get my voice mail) is a snippet from the great old Doors song "Roadhouse Blues": "Keep your eyes on the road / And your hands upon the wheel." Remember it? Pretty damned good advice if you're driving a vehicle that weighs 52,000 pounds.

That little baby cost me a cool $1.7 million, and it's been worth every penny of it.

The 30-30 Golf & Country Club

As anybody who's ever stuck a tee in the ground knows, the game of golf is famous for an atmosphere that's more exclusive, less accessible, and harder to get into than a green jacket at Augusta National. You've got your private golf clubs where even lifelong members spend years on a waiting list hoping for a Saturday-morning tee time or a seat at the "good" end of the club bar.

Okay, maybe there aren't as many places quite that tight-assed anymore, but there are still enough of them to make me want to puke. You know the kind I'm talking about. The country clubs that are so busy trying to be fancy and restrictive that they lose sight of what golf's supposed to be all about.

Hell, if Bay Ridge in Dardanelle had followed the same policies and practices of your average Blueblood Golf & Country Club back when I was a kid, I'd be finishing off an illustrious career as an NFL place kicker who didn't know a 5-iron from a gin whistle.

(Hmmm. Come to think of it, that wouldn't have been a half-bad way to have spent the last 20 years, what with the NFL playing only one game a week and the season only being six months long and all. That'd leave plenty of time for hacking around my local public course, and no cuts to worry about.)

But I know that people like to feel that they belong to something special, so let me tell you a little members-only deal called the John Daly 30-30 Golf & Country Club.

The 30-30 Golf & Country Club has affordable dues—$0 initiation fee, $0 per annum—and it's about as exclusive as they come. Total membership: 1.

That would be me, in case you were wondering, which means that I'm also chairman of the membership committee, which in turn means you're a shoo-in for membership, should you wish to join. All you have to do is abide by the club rules implied by the name:

- Never show up at the golf course more than 30 minutes before your tee time;

- Never smoke more than 30 cigarettes per round.

Got it? 30-30 has been my motto and modus operandi for over 30 years now, and I'm saying it's a hell of a good name for the only private club that would have me as a member.

Let me clarify a couple of things while you consider joining.

First, early on in this book, in the section called "Get Ready to Play" (see page 5), I talk about a whole bunch of things to do before you tee off, but please notice that I stipulate that you should be able to do *everything* you need to do in 30 minutes, max.

Second, please understand that I am *not* suggesting that you smoke 30 cigarettes per round. That might be tough, especially if you're a nonsmoker now. All I'm saying is that you can't smoke *more* than 30 cigarettes per round and still be a member in good standing of the 30-30 Golf & Country Club. (Hey, if I can cut back that far, so can you.)

So welcome to the 30-30 Golf & Country Club. No waiting list, no dues, no dress code, a member-guest tournament every weekend—and just two rules.

⸎54⸎
That's a Givee

The worst shot in golf, bar none? No, it's not the banana slice that comes to rest just past the OB stake on the 18th hole with Sunday's match (and a week's bragging rights) on the line, and it's not the duck hook that takes out that little old lady walking her dog on the sidewalk along the 12th hole. (She should have known better.) And no, it's not the topped drive or the shanked 9-iron or the chili-dipped wedge or the skulled sand shot that flies the green. (Shit happens.)

In my book—and that would be the one you have in your hands—the absolutely worst shot in golf, bar none, no question about it, is the putt that comes up three inches short.

Think about it for a second, and I bet you'll agree. You don't have to take a full swing. You don't have to worry about the wind. You don't have to do a single damned thing except give the little white ball a chance to drop into the hole. That's Job Number 1. And there is no Job Number 2.

As for just about everything else that can possibly happen in the game from tee to green, golf has a saying that captures the situation perfectly. You may have heard it: "Never Up, Never In."

(Yeah, I know. That saying also applies to a somewhat more intimate masculine failing, but at least that one doesn't cost you a stroke—and maybe the hole in match play.)

Ask any pro: Nothing, and I do mean *nothing*, chaps his (or her) ass more than rolling a putt dead on line 20 feet across the green only to have the sucker come up just short of a birdie. Tap in for a par? That's a consolation, but it'll be a whole lot easier to take if you're doing the tapping from *the other side of the hole*.

Amateurs have a familiar name for any putt from one inch to one foot (or more, sometimes much more). It's probably the most frequently invoked single word in the game. It is, of course, the word "gimme."

Sometimes a gimme is claimed as a natural right, as in "That's a gimme." Sometimes it's sort of begged for, especially when it's like three feet away in no-man's-land: "gimme?" And sometimes it's conceded by your playing partner: "That's a gimme, pick it up."

Fine. I'm all for gimmes. They speed up a slow game.

They make perfectly good sense if everybody on the green goes along with them. And, provided you have reasonable standards—"inside the leather" works for me—then you're not screwing with the integrity of the game, no matter what the USGA says. Hell, I wish we could claim gimmes on the Tour. As is, too many guys spend as much time sweating a 2-footer as they did lining up the 35-footer that got them to two feet in the first place. Take your gimme and move on to the next tee.

But I would put one super-important condition on the giving and taking of gimmes, one that would radically alter the game, impose a harsh penalty where one never existed before, go a long way toward fixing the worst shot in golf, and add a new word to the golf language: "givee."

You getting my drift? I say that if you leave a putt, *any* putt, a little short, then you pick it up, just like a gimme; but you *add* a stroke to your total for the hole. You take your gimme, but then you add on a givee. In effect, you take a penalty stroke for not having the cojones to get the ball to the hole in the first place.

Let me make that 100 percent clear, if it isn't already. If you roll your approach putt a little *past* the hole, you take your gimme (provided it's within your regular foursome's accepted standards), mark down your par 4, and move on.

But if you leave that first putt a little *short* of the hole— "Never up, never in," remember?—then you take your gimme *and* you give yourself a givee for a bogey 5. Think of that extra stroke as a kick in the butt for leaving it short.

Think about the consequences for a minute. How much less likely are you to leave your next 20-footer short? How much more likely are you to spend a few minutes on the practice green from now on making sure you get the ball to the hole?

My prediction: The givee, when adopted by the USGA, as it surely will be when the suits read this, will make every golfer in America a better putter.

. . . And Other Daily Thoughts
to Guide Us

Naturally enough, after reading what Jimmy Demaret had to say about golf and sex in *Golf Quips 2008 Calendar* ("Golf and Sex are about the only things you can have fun doing without being any good at"), I started flipping through the rest of the year. Here are a few things I came up with:

> "If they taught sex the way they taught golf, the race would have died out years ago."
>
> —JIM MURRAY (DECEMBER 18)

> "I've never missed a putt in my mind."
>
> —JACK NICKLAUS (JULY 30)

> "If you drink, don't drive. Don't even putt."
>
> —DEAN MARTIN (MARCH 31)

> "Golf is like a love affair with a hot woman. If you don't take it seriously, it's no fun; if you do take it seriously, it breaks your heart."
>
> —ARTHUR DALEY (MARCH 14)

And there were a couple of good ones about me:

"John Daly's driving is unbelievable.
I don't go that far on my holidays."

—IAN BAKER-FINCH (SEPTEMBER 12)

"John certainly gives it a good hit, doesn't he? My Sunday best is a Wednesday afternoon compared to him."

—NICK FALDO (SEPTEMBER 17)

There's even one in there from my playing partner:

"Keep your eye on the club. Nothing is more embarrassing than to throw a club and then have to ask a playing partner where it went."

—GLEN WAGGONER (JANUARY 17)

Hey, you need a desk calendar, and you're going to be thinking about golf every day anyway, so why not the Golf Quips 2008 Calendar?

(Note: the preceding was an unpaid, apolitical public service announcement.)

→56←
Stormy Weather

One of the things I like best about the British Open is the weather. I'm not kidding. I really love it when the wind blows hard. The year I won at St. Andrews, 1995, it was blowing 30 to 40 miles an hour all four days. And from different directions, all in the same day. Not much rain, just some one day, but plenty of wind. Man, it was great. You had to factor in the wind on every single shot. It affected your club selection, your ball trajectory, your strategy, everything. I loved it. And the great thing is, you can count on it there just about every year.

"Does It Bother You That You're No Longer the Longest Guy Out There on the Tour?"

No, not one bit. It bothers me where I've been recently in scoring average and putting and the money list and tournaments won. But it doesn't bother me at all that Bubba Watson and J. B. Holmes and some other guys are air-mailing me by a few yards these days. Hey, I'm a little older now. You've got to figure that some of these young dudes would step up to the plate and flex their muscles.

Look, driving distance is just one part of the game. It's sexy and all that, and it's still a hell of a lot of fun to . . . well, grip it and rip it. But it's also the part of the game that's changed the most in the last five to six years, so it's hard to compare apples with apples. Remember, for a lot of years there I was the only guy who averaged 300 yards off the tee. Then, in 2003, membership in the 300 Club jumped to 9. In 2004, 15 guys averaged 300 or more. And then in 2005, it took another huge leap to 26 guys averaging 300 yards or more off the tee. From one guy in 2002—that would be me—to 26 just three years later.

It looks like it may have leveled off a bit. At the time this book was going to press, "only" about a dozen guys out there were averaging 300-plus yards off the tee. But still, that's a

lot more than the one who was doing it for a lot of years.

How come the huge jump? It's pretty obvious: the equipment. More guys going long, and the definition of long getting a lot longer, because of the new drivers we're all using. You look at some of the newest drivers these days, mine included, and they look like Volkswagen Beatles at the end of a fishing rod. In titanium.

Sometimes I think it would be cool if the Tour told us we all had to go back to persimmon. For everybody thirty-five years old and older out there who started playing golf when he was kid, persimmon would be going back to the beginning. And we'd all be starting on the same page.

But the fans wouldn't like it, all the young studs who were raised on metal woods would hate it, the club manufacturers would take it to court, and millions of amateur golfers—that would be you and your pals—would start a revolution. And, at the end of the day, I really wouldn't like it either.

Fact is, you can't turn back the clock.

Besides, it would be hell trying to figure out what to hit on your second shot.

"Take Dead Aim."

That's the most famous line from the most famous golf book of all time, *Harvey Penick's Little Red Book*. It captures perfectly the single most important challenge in golf: knowing exactly where you're going, and setting up in the best possible way to take you there.

Thank you, Mr. Penick.

Short Stuff

Everything about the setup for your short-iron shots should be keyed to delivering a descending blow to your golf ball. Your short irons (7, 8, 9, P) have a lot of loft—*duh!*—the better to deliver high-trajectory shots that land softly. Here's the best way to make that happen:

1. **Ball Position:** Center of stance.

2. **Hands:** At address, well ahead of a perpendicular line drawn up from your ball.

3. **Width of Stance:** Shoulder width, between your heels.

4. **Weight:** Roughly two-thirds on your left leg, one-third on your right.

5. **Open Up:** Draw your left foot slightly back from the target line, no more than two to three inches. Why? A slightly open stance helps you deliver the blade of your short iron precisely square to the target line on impact.

Where To? How Far?

PUTTING 101

The golf hole is 4.25 inches wide. The golf ball is 1.68 inches in diameter.

Think about that.

Problem is, if you think about those dimensions too much, it could drive you a little nuts, because the margin for error in putting is so doggone small. If you're 20 feet from the hole on a dead-flat green, and your putter head meets the ball so that it rolls dead center to the front edge of the hole (Point A to Point B), the ball drops in with 1.28 inches

on either side to spare. But if you stroke the ball just 1.29 inches to either side of that dead straight line to the front edge, you're putting again.

You know what a 1.29-inch variance from Point A to Point B looks like over a distance of 20 feet? Nothing. That's why the margin for error in putting is so doggone small. You can't see it. You have to *feel* it.

I know that sounds obvious, and it is, but that business about margin of error bears repeating, and repeating, and repeating, because really understanding it in your gut is the key to good putting. You've got to understand it in your gut and get over it, because if you don't accept it and focus on how to make the best of it, you might as well give up the game right now.

If you can't putt, you can't play. Period.

LEARN TO READ

If all greens were absolutely flat, all you'd have to worry about was how to stroke a golf ball along a straight (if imaginary) line leading directly to the hole. Not as easy as it sounds, but learnable with practice. Lots of practice.

The problem, of course, is that all greens are not absolutely flat. In fact, *no* green is *absolutely* flat. Many have more curvature than your average stripper. That means you've got to stand behind your ball, figure out where it's going to go if your putter's face encounters it squarely and solidly, and decide on the "line" you're going to take from Point A (your ball) to Point B (the front center edge of the hole).

How are you going to learn to do that?

You guessed it: practice, practice, practice.

Problem is, figuring out which way(s) your putt is going to bend on you is a piece of cake compared with the next thing you have to settle on: speed.

Uphill or downhill? With the grain of the grass or against it?

You may have nailed the break—the direction your ball is going to move after you strike it. But if you then hit your ball too hard, it'll roll right through the break—that is, it won't break as much as you'd figured, and it'll sail past well wide. Hit it too softly, though, and you've got yourself another problem: Your ball will take too much of the break and curl away well before it reaches the hole.

Discouraged? Don't be. It's every bit as hard as it sounds, maybe even harder, but the payoff—getting close enough for tap-in pars most of the time and occasionally seeing one of those little babies drop in for a birdie—is well worth all the anguish and heartache. Not to mention all the practice, practice, practice.

Direction and speed are the two related but distinct components of your read. Keep them apart in your mind. Decide on how much break your putt is going to have and commit on the line your ball needs to take. Then decide how hard you need to stroke your ball along the line you have selected. First the line, then the speed. Related, but separate components of your "read." Commit to the first, then to the second, and then make solid contact.

Piece of cake.

As for a full shot, I personally employ and strongly recommend a reverse overlapping grip, only instead of overlapping the little finger of my right hand over my left, it's just the reverse: left little finger over the right. Hence, the clever name—*reverse overlap.*

On full shots with your other clubs, you need maximum security to keep the club from coming out of your hand, and you get that with the standard overlapping grip, right little finger over left index finger.

On a putt, though, the club sailing out of your hand and into a nearby lake isn't a clear and present danger—unless you think the sorry piece of crap really needs to die—so overlap the other way: left index finger over right little finger, which leaves your entire right hand on the club handle.

Snug and comfortable, with the grip predominantly in your fingers. This will, I submit, give you the best possible feel for the putter. And putting, you won't be surprised to learn, is *all* about feel.

GET SET

How do you align your body to give yourself the best chance of bringing the putter head directly along the target line that you have "read" for this particular 20-foot putt?

It depends.

Tom Watson, one of the greatest putters in history, always

set up with his body perfectly square to the target line. He felt that alignment gave him the best shot at bringing the putter head back and forward along the target line.

Jack Nicklaus, also one of the great putters in history, always set up with a slightly open stance, his feet, hips, and shoulders aligned slightly left of the target line. He felt that alignment gave him the best shot at bringing the putter head back and forward along the target line.

Is there an echo in here? No, I was just trying to make the point that two great golfers could have a fundamental disagreement on something so basic as the best way to set up to putt.

Me? I've always preferred the slightly open stance. I think it helps me deliver the putter head squarely to the ball with a solid, piston-like movement toward the hole controlled by my arms. See, I want to make sure my wrists are just going along for the ride. With so little margin for error in trying to propel the ball from Point A to Point B, I want to be sure that my wrists have no say in what happens.

Weight? Shifted slightly forward to my left side.

Ball position? Off my left heel, so that my putter head makes contact at the bottom of my stroke.

Hands? Just ahead of the ball. Again, the idea being that contact comes between putter head and ball at the very bottom of my stroke to insure a solid hit.

Sound like I was rushing a little there at the end? Well, I was, in order to make a point, and that point is that you shouldn't. I don't mean you should slow down to a crawl just because you've reached the end of the line for this particular hole—that is, the green. You see that *way* too often on Sunday on TV: guys finally taking their stance over the putt and then freezing, practically turning into a statue over the ball, as if they'd forgotten altogether that it was coming up on cocktail hour.

Pace and rhythm. Rhythm and pace.

Make your read from behind your ball. (And from the sides and the other side of the hole, too, if it's an especially tricky one and $10 is riding on the outcome.)

Take your stance at the ball.

Putt the ball.

Really, it shouldn't take all day.

Pace and rhythm. Rhythm and pace.

All that's left is to retrieve the ball without splitting your britches, and then making that nice, soft, underhand toss to the gallery. I'm guessing you don't need any tips on how to do that.

Maintain the Bermuda Triangle
(Psst! And the Bent One, Too)

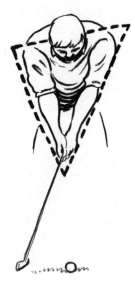

The actual putting motion is carried out by a triangle—the one formed by your shoulders, arms, and hands during the backswing—acting in harmony as *one piece*. I can't stress this enough. If you let that triangle break down at any point, you're inviting your wrists and hands to join the putting party, and they're not invited, remember? (At least not on any putt from 20 feet or so; on longer putts, it's okay to

let the wrists join in—a little—to keep your putting motion from becoming too wooden.)

Believe this: The best way to keep your putter head moving *along the target line* during your putt is by turning the job over to the triangle formed by your shoulders, arms, and hands.

Golf Is a *Game*.
So Have Some Fun Out There.

Because I love music so much, and because so many musicians love golf, I've had the privilege of playing golf and making music with a lot of great guys who I also happen to be listening to all the time. Guys like Johnny Lee, and Darius Rucker and all the Hootie and the Blowfish gang. I mean, we play whenever we get a chance—golf *and* music.

That's my idea of fun golf. The rest of the time, golf for me is work. Hey, remember that "golf" spelled backward is "flog," and nobody knows that better than a pro who starts the back 9 on Friday at even par when the projected cut is minus 2.

Another good friend of mine who's also a great musician has just taken up golf, and I believe Kid Rock will become a terrific golfer if he can find the time for it. We met in Memphis about seven years ago, and since then we've hit a few balls together. He's just now starting to take it up seriously. Kid is *very* athletic. We've played a lot of pool basketball, which the way we do it is a cross between regular hoops, water polo, and trying to drown each other.

If he takes that athleticism and applies it hard to golf, and makes enough time in his schedule for some serious practice, I predict he could be down in the single digits in a year. I'm serious. He's that good an athlete.

I hope he does become a serious golfer, because then you'll see him in high-profile pro-ams like the Hope. And that would be great for the game, because you can count on one thing: He'll be wearing that great signature black hat of his.

That would be beautiful.